General
David

BRUEGEL

Every Painting

Tiziana Frati

translated by Jane Carroll

RIZZOLI
NEW YORK

Foreword by the General Editor

Several factors have made possible the phenomenal surge of interest in art in the twentieth century: notably the growth of museums, the increase of leisure, the speed and relative ease of modern travel, and not least the extraordinary expansion and refinement of techniques of reproduction of works of art, from the ubiquitous colour postcards, cheap popular books of colour plates, to film and television. A basic need – for the general art public, as for specialized students, academic libraries, the art trade – is for accessible, reliable, comprehensive accounts of the works of the individual great masters of painting; this has not been met since the demise before 1939 of the famous German series, *Klassiker der Kunst*; when such accounts do appear, in the shape of full *catalogues raisonnés*, they are vast in price as in size, and beyond the reach of most individual pockets and the capacity of most private bookshelves.

The aim of the present series is to provide an up-to-date equivalent of the *Klassiker* for the now enormously enlarged public interested in art. Each volume (or volumes, where the quantity of work to be reproduced cannot be contained in a single one) catalogues and illustrates chronologically the complete paintings of the artist concerned. The catalogues reflect as far as possible a consensus of current expert opinion about the status of each picture; in the nature of things, consensus has yet to be reached on many points, and no one professionally involved in the study of art-history would ever be so rash as to claim definitiveness. Within the bounds of human fallibility, however, every effort has been made to achieve both comprehensiveness and factual accuracy, while the quality of reproduction aimed at is the highest possible in this price range, and includes, of course, colour. Every effort has also been made to hold the price down to the lowest possible level, so that these volumes may stay within the reach not only of libraries, but of the individual student and lover of great painting, so that they may gradually accumulate their own 'Museum without Walls'. The introductions, written by acknowledged authorities, summarize the life and works of the artists, while the illustrations place in perspective the complete story of the development of each painter's genius through his career.

David Piper

Introduction

'The peasants' painter', Bruegel was called at the beginning of the seventeenth century by his first biographer, Carel van Mander. This judgement referred both to the artist's presumed origins and to the fact that peasant life was the theme he turned to most often in his paintings. For about four centuries he continued to be known as a 'peasant painter', and as a skilful imitator of Bosch – despite the words of Abraham Ortelius, geographer and humanist, Bruegel's contemporary and close friend: '. . . he has painted . . . things which cannot be painted.'

By the end of the nineteenth century, Romantic critics were resuscitating many artists who had been neglected by the academic tradition. The rediscovery of Bruegel, who had been relegated, as a 'popular painter', to the category of a minor artist, began in earnest. Hymans (1890) referred to him as 'the Hogarth of his time', Riegl (1902) described him as the initiator of non-religious art in the Netherlands. The first catalogue of Bruegel's works appeared (Romdahl, 1904–5), followed by the study by van Bastelaer and Hulin de Loo (1907), a thorough and pathfinding piece of research, rich in detail, although naturally not compiled according to the strict criteria laid down by modern art history.

Numerous new assessments of Bruegel followed: peasant, bourgeois, humanist, philosopher, genre painter, landscapist, realist; and so did appraisals of his individual works, from all angles – founded on historical, literary, sociological and esoteric principles.

We know neither the place nor the date of birth of Pieter Bruegel (his surname seems to have originally been Brueghel, but he himself altered it, in about 1559). His early biographer, van Mander, says that the village where he was born gave his family its name and that it was near Breda. There are in fact two villages called Brueghel, but neither is near Breda. More likely to be correct is the information provided by a contemporary of Bruegel, Ludovico Guicciardini (grandson of the better-known Francesco), an Italian who lived and died in Antwerp. In his *Descrittione di tutti i Paesi Bassi*, 1567, he said Bruegel came from Breda. An approximate birth date

can be deduced from the first certain date documented: 1551, when Bruegel was accepted as a member of the Antwerp guild of painters. Since painters had to be at least twenty-five years of age, and of proven skill, before they could become members, it seems likely that Bruegel was born some time between 1525 and 1530.

He was possibly apprenticed to Pieter I Coecke van Aelst, an erudite painter and Latinist, who had been in Italy and Turkey. From him Bruegel would have acquired a sophisticated cultural grounding, steeped in humanism. The way his art subsequently developed and the ease with which he absorbed all his experiences, supports this theory about his early training. In Coecke's workshop, Bruegel might also have learned the technique of tempera on canvas through his master's wife, Mayeken Verhulst Bessemers, painter and miniaturist from Malines. The technique was much used at Malines instead of the more costly tapestries. At any rate it was at Malines that he had the chance to put his training into practice when in 1551 he worked in Dorizi's workshop on the triptych for the cathedral of St Rombaud, his first important commission.

In 1552 he left for Italy. The Italian tour, part of which he undertook in the company of Marten de Vos, was an obligatory part of the cultural training of Netherlandish painters at that time, when admiration for the great masters of the Italian Renaissance was steadily growing. The drawings, and a very small number of paintings, now lost, but which we know existed, which Bruegel made in this year tell us that he crossed France, stopping at Lyons, and then went to Reggio Calabria, Messina and perhaps even Palermo. The following year, in Rome, he met the distinguished miniaturist Giulio Clovio, and from him he learnt the art of miniature-painting.

In this period Bruegel's interest centred on landscapes – as can be seen from the painting *The Calling of the Apostles* (No. 1) (to which Marten de Vos may have contributed the figures) and a series of impressive drawings of Alpine views. These are majestic, cosmic panoramas in the Flemish tradition, but

inspired with the young painter's own robust and individual vision.

He returned home between 1553 and 1555. Antwerp was a prosperous city, growing steadily, thanks in particular to its port where the great merchant ships from the New World landed. The intense commercial activity was not only the source of widespread economic well-being, but also of continual and invigorating cultural exchanges. Moreover, it had enabled an easy spirit of tolerance to grow up, still unthreatened by the domination of Catholic Spain.

It was a favourable time for the arts. Bruegel began to work with the 'The Four Winds', the famous Antwerp workshop of the publisher Hieronymus Cock. He may have already had contact with Cock even before his journey abroad and indeed it is possible that the publisher suggested the trip as a means of enriching his workshop's repertory of landscapes.

Between 1554 and 1555 Bruegel devoted himself essentially to drawing. He made numerous drawings of mountains which are more than just memories of sights he had seen during his journey: they also show his knowledge of Italian art, particularly of the Venetians.

Meanwhile the political situation of the Netherlands was worsening, as Philip II of Spain (who had succeeded Charles V in 1556) carried out increasingly fierce repression against the Reformist religious movements. This repression provoked especially strong reaction among the cultured circles, where humanism and the teachings of Erasmus had led to a new faith in human reason and in tolerance. It may have been as a result of these profound disturbances that Bruegel altered his choice of themes (although market considerations could also have played a part): he now began to turn his attention to Bosch's paintings.

Bosch's demonic monsters symbolize the degenerate, obsessive effect which evil has on man. They are the dark creatures of Satan which during the whole of the Middle Ages tormented and persecuted human beings. But they could also evoke the atmosphere of a nightmare – the nightmare in which a free man, living in opulent Antwerp in the sixteenth century, felt oppressed and crushed by intolerance and blind superstition, and divested of his liberty by foreign domination.

Inspired by the master from s'Hertogenbosch, Bruegel made drawings for numerous engravings with a satirical or moralizing theme (the *Temptation of St Anthony*, the series of *Seven Deadly Sins*), in which Bosch's anguish seems to be tempered by irony and satire/comedy.

The human figure now becomes an important element in Bruegel's paintings. The figures are those of people caught in the most banal, grotesque or downright unpleasant actions; they are not analysed as individuals, but presented as examples of humanity in general. It seems that this was not merely fortuitous, since the artist's interest is directed not at a particular individual but at man in general, his suffering and erring ways; or, to give it a more specifically political interpretation, at the ills suffered by him.

The taste for landscape reappears, here and there, in subsequent works: for example it is the main element in *River Landscape with the Parable of the Sower* (No. 3) of 1557 and in the *Landscape with the Fall of Icarus* (No. 6), which is known in two versions. The former uses traditional Netherlandish high viewpoint, but achieves a greater vigour through the density of the foreground area, with the undulating movement of the land.

The second painting is superb: in the broad landscape bathed in light which is reflected off the white mountains in the background, in the sparkling of the sea and the fleece of the sheep, the only sign of the mythical event is provided by the legs of the unfortunate Icarus, waving out of the water (at bottom right); no one is taking any notice. More or less contemporary is the *Harbour at Naples* (No. 5), recognizable from the mass of the Maschio Angioino and from the remains of the Castel dell'Ovo, on the left; the boats, sailing on the open sea, are painted with observant and minute care, demonstrating the artist's great interest in ships (he also made eleven engravings of ship 'portraits'). This interest may have been stimulated by his friendship with the geographer Ortelius.

One constant factor in Bruegel's life seems to have been his openness to stimuli, his flexibility, his ability to absorb new suggestions, examine experiences and appro-

4

priate them, sometimes perhaps putting them aside, to take them up again and reinterpret them some years later. For a long time he was regarded – as we have seen – as a 'popular illustrator', and in the works he did between 1558 and 1569 he does in fact reveal an exceptional talent as illustrator or rather narrator. His first important figure painting, done in 1559, was on the theme of the *Netherlandish Proverbs* (No. 12) – a subject he had already tackled in a series of twelve roundels (No. 11) (although the authenticity of these is not accepted by all critics); in each of these twelve a proverb is personified/acted out by a single figure. The theme had become a topical one since the religious controversies and the spread of humanism had, for quite different reasons, drawn attention to popular lore, even if only for the purpose of discrediting it. (An illustrious example is to be found in the *Adagia* of Erasmus, an extensive collection of Latin and Greek maxims together with a commentary.)

The composition of the *Proverbs*, though not very well balanced, is extremely lively in colour and movement. Each of the small figures or groups of figures, densely packed into the picture, illustrates a popular saying (there are about 120 in all). The man shearing the sheep beside a low wall while his companion is trying to shear a pig, means something like: 'it's no use copying an example without using your intelligence'. The woman placing a blue cloak over her husband's shoulders illustrates a popular phrase which means she is being unfaithful to him. The person kneeling down, half inside a globe, represents the hypocrite or opportunist who adapts himself to any situation, in other words, 'according to the way the wind blows' (the image of the glass ball symbolizing the world appears many times in Bruegel's work). A reference to abundance is provided by the girdle cakes which are growing on the roof (top left). Many of the little scenes are now almost impossible to understand. However, the overall significance seems to be gathered together in the image of the lamp hanging upside down on the wall of the house on the left; it seems to say: the world upside down (the panel was recorded with the title *Le Monde renversé, représenté par plusieurs Proverbes et Moralités* in the inventory of the possessions of Peter Stevens of Antwerp [1668], a rich collector, who also owned ten other works by Bruegel).

The other two large-scale paintings of this period, the *Battle between Carnival and Lent* (No. 13) and *Children's Games* (No. 14), are in the same descriptive vein. In the former, the treatment of the composition is more successful than in the *Proverbs*; the way the figures are thinly spread out, either isolated or in groups, recall the work of Bosch and the scene is placed within a more robust and coherent architectural framework. In the foreground, in the centre of the scene, Carnival and Lent face each other in the grotesque duel; they are supported by retinues representing the ceremonies and personages typical of the two periods of the calendar. Here and there are Bruegel's usual human scenes, to which no one pays any attention: children absorbed in their games, and the cripples and lepers, a painful reality of the age. There are some brilliantly effective episodes from everyday life, such as the woman leaning over the improvised hearth to cook her girdle cakes, or the fish stall, with a housewife approaching, about to make her purchases. This is the so-called 'Peasant Bruegel' emerging, with his affectionate interest in humble people, and in their quiet, humdrum activities.

The composition of *Children's Games* is similar, with its bold uses of perspective in the long street leading off on the right – this is obviously linked with the lessons learnt from Serlio, whose treatise on architecture had recently been translated from the Italian. The scene is enjoyable on one level for its documentation of a large repertory of children's games, most of them still surviving (hoops, leapfrog, somersaults on the grass and riding astride a fence – all of these are timeless activities). The critics have interpreted it (as they have the *Proverbs*) in a number of ways. Some have thought it an allegory of childhood, or an allusion to culpable human stupidity, and it has even been interpreted as having an alchemic meaning, representing the golden age of the philosopher's stone.

The presence of alchemical references in Bruegel's work cannot be ruled out, and it is possible that he got the idea of the symbols from his study of Bosch's paintings. In any case in the sixteenth century there was still a

very keen interest in alchemy: it represented a meeting point between scientific research, current religious issues and the penchant for magic. The basic aim of alchemy was the transformation of base metals into gold, but it also implied a corresponding process by which man was purged of evil. In this latter sense it is possible to seek an alchemical content in Bruegel's work, as a Flemish scholar, van Lennep, has recently done.

After a break of about a year (there is no information about Bruegel's activity during 1561), the painter returned to work with a changed attitude: he began to experiment with new and varied techniques. In order to express his state of mind, now more troubled and pessimistic, he turned back to the manner of the old master, Bosch.

The *Two Monkeys* (No. 16), which loom large and solitary against the faded landscape in the background and enclosed within a stone frame, express clearly the anguish of a people in servitude; or they may stand as an allegory of man enslaved by his own sin. An answering message of salvation is found in the monochrome *Resurrection* (No. 17), which shows two episodes, the announcement to the pious women and the Risen Christ (van Lennep perceives an esoteric meaning here too: he points to symbols which represent the genesis of the philosopher's stone). The *Suicide of Saul* (No. 15) marks the beginning of a new way of treating the human figure. The majesty of the glowering, rocky landscape and the vertical tension of the trees are contrasted by the dense and leaden mass of the soldiers, with lances aligned and crossing in a densely woven pattern. On the left the biblical episode is taking place, isolated and ignored, as in previous paintings by Bruegel.

The *Fall of the Rebel Angels* (No. 18) is peopled by the monstrous, infernal beings of Bosch, astonishing creatures, half-fish, half-man, bats with women's faces, winged fish and reptiles: extraordinary figures of a Nordic fantasy which, together with a number of other creatures, also show the influence of the medieval bestiaries. In the midst of this absurd mêlée, a fragile St Michael dressed in armour and a dazzling, fluttering cloak, brandishes his sword. From above, white-robed angels fly down to help him; they form part of a superb chromatic effect which permeates from the refulgent centre of light above to the brownish tones below. The picture is the antithesis of an Italianizing painting on the same theme made in 1554 for Antwerp cathedral by Frans Floris (who like Bruegel was a collaborator in the Cock workshop). While in the *Fall* the attractive use of colour is more important than the reminder that sin will be punished, the same cannot be said for the *Triumph of Death* (No. 19). During his journey to Italy, Bruegel may have seen the frescoes in the Camposanto at Pisa and at the Palazzo Scláfani at Palermo, on the same theme. Nevertheless, the picture he painted was entirely his own. It shows a barren heathland bordered on the horizon by flames and smoke; the only vegetation is provided by the gallows and stakes on which corpses are displayed. Against this background a nightmarish, desolate vision is unfurled. Fate's dark, relentless pursuit is represented by the dense army of skeletons advancing from the right, while the death cart moves along on the left and a group of skeletons wrapped in white sheets blow trumpets.

Fire and smoke and horrific infernal creatures in the style of Bosch are also found in one of Bruegel's most debated paintings, the '*Dulle Griet*' (No. 23). This title was given to it in 1604 by van Mander, who said it showed the foray into hell of 'Mad Meg' – Griet, the character of popular Nordic tradition who embodies the worst defects of the female character, spiteful malevolence and unbridled greed. In the middle of the composition is the dreadful woman, staring ahead with an obsessed look. She is dressed as a peasant but protected by cuirass and helmet. In her left hand she holds a nonsensical bundle of precious objects and cooking utensils and she is striding forward with a sword in her other hand. In front of her, from the sharp-toothed mouth of a man-fish-building covered in scales, flows a stream of monsters. To the right of Griet, on the roof of a shed, a grotesque figure is ladling coins out of its egg-shaped bottom; below, a crowd of women are scuffling to grab the money. The novelty of the theme and the great number of symbolic motifs has given rise to all kinds of interpretations – some based on alchemy, others historical or political – but all serving

to document the richness of content in Bruegel's work.

It seems likely that the artist wanted once again to illustrate human vice and stupidity (as he had done in the *Proverbs* and the *Battle between Carnival and Lent*), but this time in a new form. Literary precedents exist, e.g. in the *Ship of Fools* by the German humanist Sebastian Brant (1494) and in Erasmus's *Praise of Folly* (1509), two satires on the weakness and sinfulness of men; the former ends with a call for a return to religion, the latter with a call for freedom for human reason. According to the findings of a recent study, the two main figures in *'Dulle Griet'* demonstrate the two types of foolishness: one a result of rage and greed, well represented by Dulle Griet, and the other, 'pleasure-loving' kind which is the consequence of continual drunkenness of one sort or another, represented by the absurd figure holding up her skirts.

There is another interpretation which sees the painting as referring to the political situation of the time: Dulle Griet is said to stand for the rebel Reformists, whom Erasmus had charged with 'ambition, insatiable avarice and warlike fury', and the figure scattering coins could be the Catholic Church, which places its own authority above everything else and which feeds violence by financing those who inform on heretics. The painter therefore censures both adversaries equally. He does the same (if an analogous interpretation is applied) in the *Battle between Carnival and Lent*, the latter figure being understood as a reference to the forces of Catholicism. Like Erasmus, Bruegel places human rationality above factions and he sees it as incorporating the values of freedom and tolerance.

In 1563 Bruegel moved to Brussels: it is not known why, but it might have been because he was obliged to seek the protection (which, however, was no longer so dependable and might even have been dangerous) of Cardinal Granvelle (despotic right arm of the Regent Margherita di Parma), an admirer of Bruegel and collector of his works.

Van Mander's biography gives us a much more anecdotal explanation: the painter had had a relationship with a young servant girl whom he rejected because she told too many lies, and now wanted to marry the young Mayeken Coecke, daughter of his former master. According to van Mander, his future mother-in-law agreed to the marriage only on condition that the couple left Antwerp.

However that may be, the parish register of Notre-Dame-de-la-Chapelle in Brussels shows that Pieter and Mayeken were married there in 1563. We know little of the couple's life together, which probably was uneventful; in 1564 their first child was born, Pieter the Younger, and in 1568 the second, Jan.

Partly thanks to the backing of the powerful cardinal, the painter quickly became part of the cultured and refined circle gathered around the court; and as a result of his contact with the humanistic culture which held sway there, he altered his expressive language. Or rather, he perfected and began to make use of the research into the monumental style with which he had experimented years earlier (for example in the *Two Monkeys*).

But he did not lose touch with Antwerp: for the banker Niclaes Jonghelinck, his old client there, he painted a large *Tower of Babel* (No. 24) (there exists another, smaller version of the work [No. 25]). The building looms against the vast landscape and almost dwarfs it. The tower is a brilliant product of human labour; but the king who has come with his retinue to admire it, and the directors of works rushing up to kneel before him, remind us of the vanity of such exaggerated pride: the astonishing achievement becomes a symbol of human folly.

The Antwerp banker also bought the large panel of *Christ carrying the Cross* (No. 26). This is an unusual composition; around a pinnacle of rock the composition spreads out in an arc which stretches into the distance; the landscape is crowded with figures and the shape of the arc is emphasized by a procession of horses and men. The overall effect is in fact one of movement, the slow, scattered progress of a mass of people.

The influence of Italian Renaissance painting is particularly evident in three paintings from this period: the *Adoration of the Magi* of 1564 (No. 27), the *Dormition of the Virgin* of the same year (No. 28), and *Christ and the Woman taken in Adultery* of 1565 (No. 29). By studying the great masters,

known through Cock's prints, and Raphael's cartoons for the *Acts of the Apostles* (or the tapestries which had been woven from them in Brussels), and contact with painters who imitated Italian art (like van Orley and Pieter Coecke), Bruegel arrived at new compositional solutions. He turned to a composition 'based almost exclusively on the human figure, using figures like walls', in the words of Grossmann, distinguished scholar of Bruegel's art. These three paintings are not imitations, however; they are further examples of his deep understanding and ability to assimilate in a very personal way the work of other artists.

The theme of peasant life reappears in Bruegel's work in a series of paintings made in 1565, and which were the pride of the collection of the banker Jonghelinck (Nos. 30–34). It is not known how many pictures the original series comprised but it presumably illustrated the months of the year, although only five have come down to us. According to some scholars, the cycle consisted of six paintings, each illustrating two months. Even in its incomplete state, the series gives an intensely felt idea of the movement of the seasons, and it is one of Bruegel's greatest achievements. Its subject is not man, but the relationship between man and nature, or perhaps nature itself, to which man adapts and in which he finds a place. The evocative power of the images derives mainly from their colours: the cold white and greys of winter, the green of spring, the sunny yellow of summer and the warm brown of autumn. It has been suggested that Bruegel drew inspiration for his iconography from the earlier Books of Hours – and certainly he knew and valued these – and also prints made for calendars. Nevertheless his paintings are steeped in a very different sense of atmosphere.

A similar use of colour is found in the *Winter Landscape with Skaters and Birdtrap* (No. 35). A small picture, painted in quiet, intimate tones, it has always been one of his most popular works and is the one most frequently copied. The hidden, menacing presence of the birdtrap has given rise to allegorical interpretations: obscure threats may lie in wait even for the young, heedless skaters, for example.

It is not possible to determine *a posteriori* the artist's precise intention and nor can we know – in the absence of any documents – whether he took an active part in political life (the mere fact that Cardinal Granvelle purchased some of his paintings has given rise to the belief that he was a collaborator with the Spanish Government and on equally dubious grounds he has been described as a member of the Protestant sect 'Schola Charitas', or Anabaptists). It is anyway certain that he was aware of the anguish of a situation which was developing inexorably towards a tragic conclusion. This occurred in 1566, when the masses, exasperated by poverty and led by the 'sowers of violence' Erasmus had spoken of, sacked the Catholic churches. The immediate response of Philip II was to send an army commanded by the Duke of Alba to inflict terror and massacre on the people.

In 1566 Bruegel painted the *Numbering at Bethlehem* (No. 37). The biblical scene takes place in the snow-covered streets of a contemporary town: Mary seated on the ass, with the cow alongside, Joseph on foot in front, carrying a large saw on his shoulder. The people are going about their normal business, the children are sliding on the ice, but there is more confusion than usual because the government officials have set up in the inn on the left, a bench for the collection of taxes. Here, then, is the scene of the tragedy, but nothing has happened yet. The dramatic sequel is represented in the *Massacre of the Innocents* (No. 38), a painting which might have been conceived as a pair with the preceding one. The setting is the same, the village square is covered in snow; in the centre a squad of mounted soldiers is gathered, while other soldiers in red tunics are tearing babies from the arms of their desperate parents and strangling them in front of their very eyes; others are chasing runaways and breaking down doors of houses, which have been barricaded in a last attempt at resistance. The painter must surely have himself seen scenes of violence something like these.

Bruegel continued to develop his compositional researches in this period between 1566 and 1567. There are a large number of figures in his paintings: large in the foreground, and in subsequent planes behind they become increasingly closed together so as to

form compact masses of people organized in precise, well-defined structures. In the *John the Baptist preaching* (No. 41) the preacher is in the background, in the midst of a dense group of astonished listeners, arranged in a circle; standing out clearly are the picturesque figures in the foreground, including a gypsy in striped cloak reading a gentleman's palm. The lively movement of the dance animates the *Wedding Dance in the Open Air* (No. 40), which is orchestrated around the rhythmic attitudes of the dancers in the front row; on the right, in the background, is the bride's table, behind which hangs a curtain with the wedding crown. The *Wedding Procession* (No. 42) moves slowly across the whole length of the painting, led by a musician; the column of men and the column of women are headed respectively by the bridegroom and bride, both wearing crowns; in the background, the ubiquitous windmill. In the *Adoration of the Magi in the Snow* (No. 44) the faithful are running up in a disorderly procession to glimpse the holy group in the stable, which the painter has placed improbably in the middle of the village street; the heavy snowfall, dotting everything with white flakes, gives unity and atmosphere to the scene.

In the *Conversion of St Paul* (No. 43) Bruegel seems to have arrived at a particularly complex compositional solution, once again uniting the landscape and the arrangement of figures. The column of warriors is marching out of the depths of the valley visible in the distance; it pauses in the centre, spreads out slightly then narrows again as it disappears among the rocks to the right. In the middle, where the two axes of the picture converge, the scene of Saul's fall is taking place; the figures of the horsemen in the foreground act as a counterbalance to it.

Bruegel's compositions become ever more geometric and perfect; there are fewer figures but the paintings are larger. A particularly significant example of this is the *Land of Cockaigne* (No. 45), the 'Luilekkerland' of Netherlandish tradition. Around the tree in the middle of the circular plateau, the three figures are arranged like the spokes of a wheel, with the tree as its hub; on it is grafted another circle – the table, laden with chickens and pies. The people are painted in monumental style; the foreshortening of the soldier is brilliantly

done. Bruegel with his usual taste for narrative uses plenty of details, all taken from folklore: the tarts covering the roof, under which the armed nobleman is sheltering, with a roast pigeon flying into his mouth; the fence made of sausages, the chicken preparing itself on the table, the pig going round with a knife already stuck in it, the ready-boiled egg rushing up to be eaten. As for the painting's significance, it is possible just to enjoy it at its face value and see it as a happy interlude of serene realism on the part of the artist in the midst of a serious political situation. However, it is also likely that by representing as the four gluttons a soldier, a peasant, a priest and a nobleman – in other words all the strata of society – Bruegel wanted to denounce their common vices.

Two masterpieces of 1568 are in a similar vein: the *Wedding Feast* (No. 47) and the *Peasants dancing* (No. 46), which may have been conceived as a pair. The delightful wealth of description in both paintings recalls that, according to the painter's biographer, van Mander, Bruegel, accompanied by the merchant Hans Franckert of Antwerp (his friend and a collector of his works), liked to go to village feasts and weddings, dressed up as a peasant and pretending to be a friend or relation, in order to get to know characters, study their customs, behaviour and movements, and then transfer his observations onto canvas.

Painted around the same time as these festive scenes of peasant life were the *Cripples* (No. 50) and the *Parable of the Blind* (No. 49), the two most intensely dramatic works of Bruegel's whole output. In both he uses a range of subtle colours, with greyish and violet tones prevailing. The *Parable* illustrates a passage from the Gospels: 'And if the blind lead the blind, both shall fall into the ditch' (Matthew 15:14). Here there are six blind men, bound to one another in their misery, staggering forwards along a diagonal which goes from the background to the foreground; one by one they will inevitably fall over like the one at the head of the line. Equally heart-rending is the group of *Cripples*, who may be lepers, as indicated by the foxes' brushes which are hung from their clothes (but some critics see these as a political allusion, because foxes' brushes were used by the *gueux*, the

anti-Spanish rebels, to indicate the governorship of Granvelle). The disease does not spare any social class: the headgear of the various afflicted men show that they include a king, a member of the bourgeoisie, a peasant, a soldier and a bishop. The parallel between disease which destroys the body and vice which corrupts humanity, leading to ruin, seems obvious. There is the same pessimistic content in the *Misanthrope* (No. 48) and it is clearly expressed in the inscription: 'Since the world is so treacherous, I go dressed in mourning.' The round shape of the painting accentuates the feeling of enclosed isolation of the figure tightly wrapped in his black cloak, from which a thief inside a globe (symbol of the treacherous world) is stealing his purse.

Right up to the end Bruegel demonstrated his ability to express himself in all kinds of forms, always adopting new and personal solutions. In the *Birdnester* (No. 51), the gigantic figure of the peasant lad in the foreground (whom some consider to have derived from Michelangelo) is contrasted with the flat expanse of the Flemish countryside. By using a pointillist technique, with short, sharp strokes, the artist manages to obtain a special vibration of light, with almost impressionistic effects.

The atmosphere of the enchanting landscape of the *Magpie on the Gallows* (No. 52) is largely produced by the light which reflects off the leaves of the trees in the foreground, gathers in the broad hollow of the valley and dissolves in a diffuse gleam along the line of hills on the horizon. In this idyllic vision, the presence of the gallows, juxtaposed to a group of peasants dancing, is a brusque reminder of mortality. The painting's meaning has not been altogether clarified and interpretations have been based to a great extent on van Mander's statement that the magpie is a symbol of evil tongues, worthy of the gallows. Also, the Netherlandish saying 'to dance under the gallows' is often cited as a possible allusion to the political situation which was growing steadily more grave and dangerous.

The *Storm at Sea* (No. 54), one of Bruegel's most intensely felt paintings, is really a sketch, or it may have been left unfinished (in which case it might be his last work). The violence of the storm is expressed with only a few elements: the extraordinary brown colour of the sky which is practically merging with the sea, the dark, hooked lines depicting the heaving of the water, the arrow of lurid light which illuminates the ship in danger and is reflected on the white wings of the gulls. Only the brightness on the horizon in which the shape of a church stands out leaves room for any possible hope of salvation.

The painter died on 9 September 1569; according to van Mander, he had been commissioned by the City of Brussels to commemorate with a number of paintings the excavation of the canal between Antwerp and Brussels, but he did not have time to finish them. He was buried in the church of Notre-Dame-de-la-Chapelle. His son Jan, when he grew up, had a tomb built for him and in it hung Rubens's *Handing of the Keys to St Peter* (which was removed in 1765). His great-grandson David Teniers III had an epitaph added, taken from the Latin verses which Ortelius had dedicated to the memory of the artist.

Netherlandish Proverbs (No. 12; detail). Not all the sayings illustrated are easy to understand; the rich man throwing coins in the water is the equivalent of our 'spending money like water'; above is a representation of 'it doesn't matter whose the burning house is, provided we can warm ourselves at the embers' ('I'm all right, Jack'); behind him, someone dragging a stool: 'to have a millstone round one's neck'.

Catalogue of the
Paintings

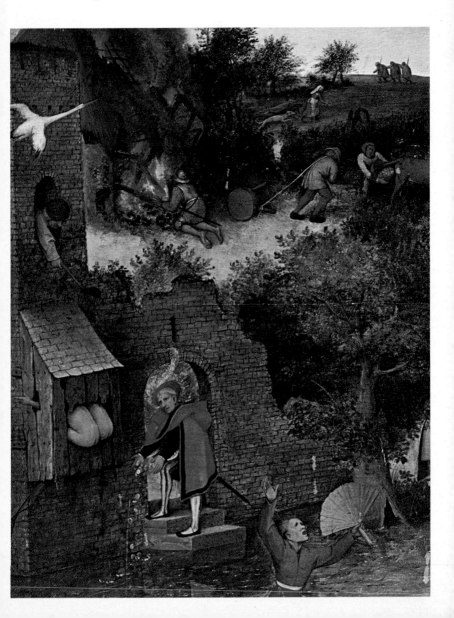

This list of Bruegel's works also includes those paintings which are of uncertain attribution but accepted by some recent critics. It does not include attributions which were definitively rejected some time ago. Also listed are those lost works for which the sources give sufficient information to make identification possible, if the occasion arose, as well as those which are documented by copies, engravings, etc.

All measurements are in centimetres.
s.d. = signed and dated

1 Landscape with the Calling of the Apostles
Oil on panel/67 × 100/s.d. 1553
Private Collection

2 The Adoration of the Magi
Tempera on canvas/ 115.5 × 163/c. 1556
Brussels, Musées Royaux des Beaux-Arts

3 River Landscape with the Parable of the Sower (or The Estuary)
Oil on panel/74 × 102/s.d. 1557
San Diego (Calif.), Timken Art Gallery

4 Landscape with the Temptation of St Anthony
Oil on panel/57.8 × 85.7/ 1558 (?)
Washington, National Gallery of Art (Kress)
Disputed attribution

Netherlandish Proverbs (No. 12) (pp. 14–15). *From the left: 'the best of women tied the Devil to the mattress' (i.e. women know more than the Devil); a man 'dashing his head against a brick wall'; in the centre, the poor man 'giving roses to the pigs' ('casting pearls before swine') and another 'covering the well after the calf has drowned' ('shutting the stable door after the horse has bolted').*

1

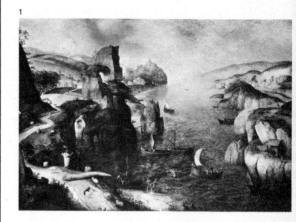

4

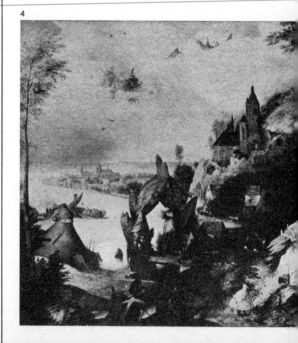

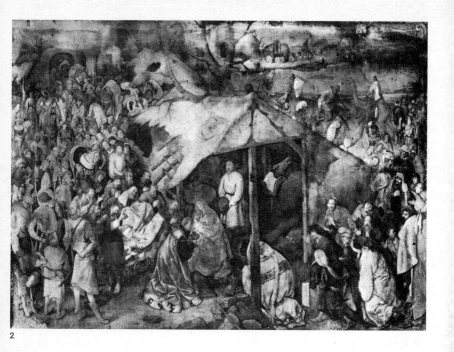

2

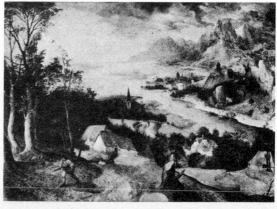

3

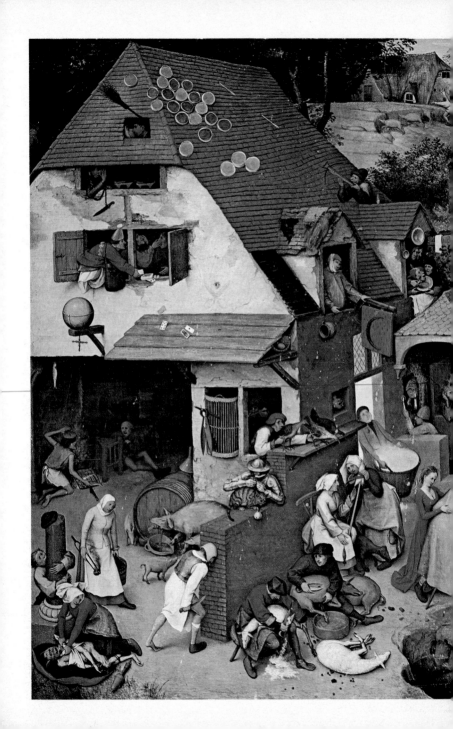

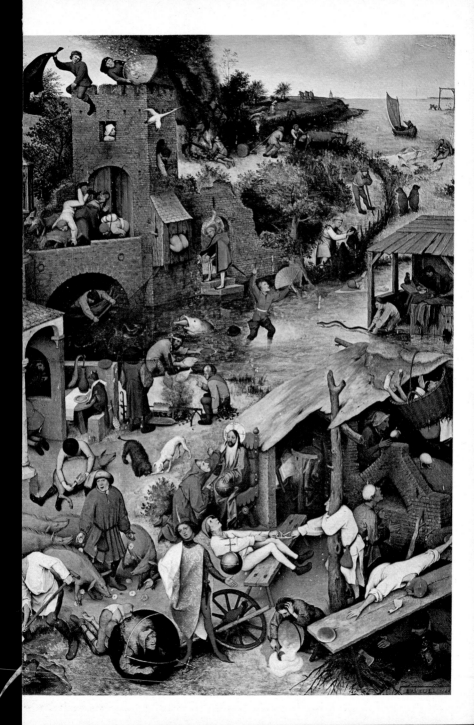

5 The Harbour at Naples
Oil on panel/40 × 70/*c*. 1558
Rome, Galleria Doria

6 Landscape with the Fall of Icarus
Oil on panel transferred to canvas/73.5 × 112/*c*. 1558
Brussels, Musées Royaux des Beaux-Arts

7 Landscape with the Fall of Icarus
Panel/63 × 90/*c*. 1558
New York, D. M. Van Buuren Collection
Version of No. 6.

8 Head of a Lansquenet
Oil on panel/diam. 16/1558 (?)
Montpellier, Musée Fabre
Attribution.

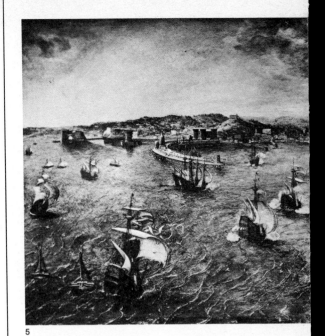

5

6

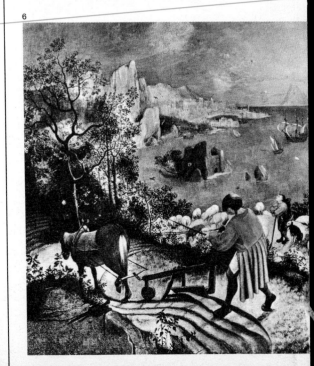

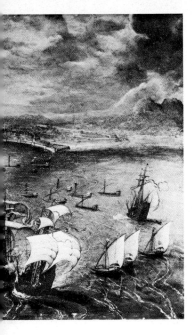

7

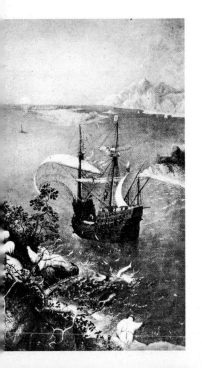

8

17

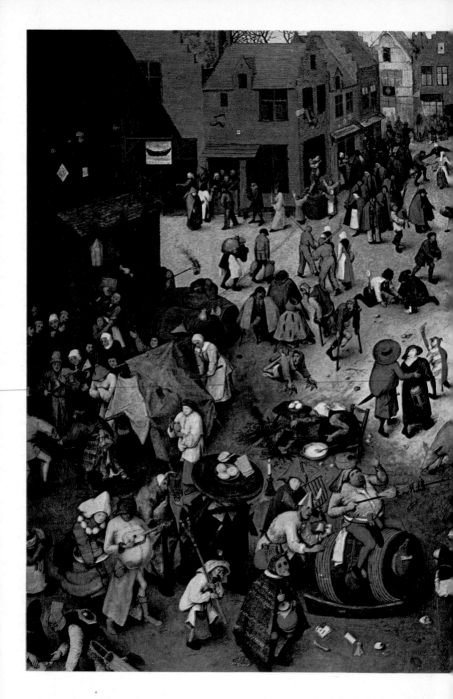

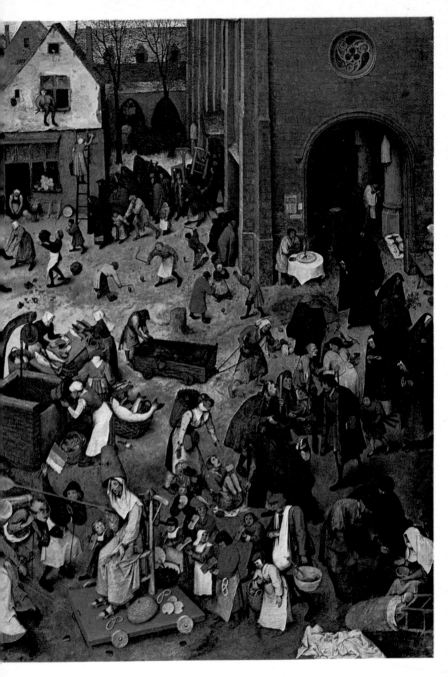

The Battle between Carnival and Lent (*No. 13*). *The two contestants in the centre get ready for the duel, both heading their own retinues; on the right, emaciated Lent, dressed in a habit and seated on a church stool.*

9 Head of an Old Man
Oil on panel/diam. 15/
1558 (?)
Bordeaux, Musée des Beaux-
Arts
Attribution.

10 A Thin Couple attacking a Fat Man
Oil on panel/24 × 37/
1558–9 (?)
Copenhagen, Statens
Museum for Kunst
Attribution.

11 Twelve Netherlandish Proverbs
Tempera on panel/
74.5 × 98.4/1558
Antwerp, Museum
Van den Bergh
Disputed attribution. The 12
wooden panels were joined
together in the 17th century
to form the present complex.
The whole complex is
reproduced here as well as the
12 individual pictures (Nos.
11 A–L) in the order in which
they are located in the whole.

10

9

11A–L

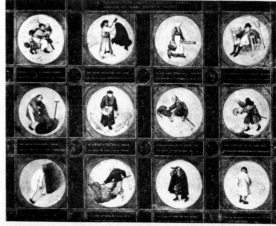

The Battle between Carnival and Lent (No. 13; detail). A well-fed Carnival advances astride a cask with saucepans as stirrups; he has a chicken pie on his head and is brandishing, as his lance, a loaded spit.

20

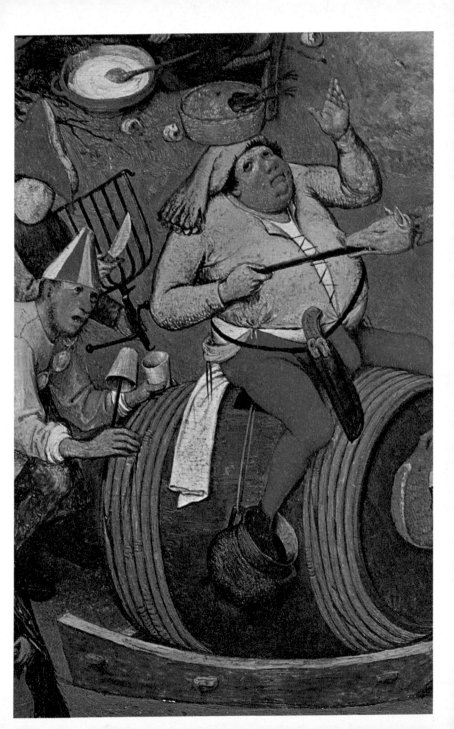

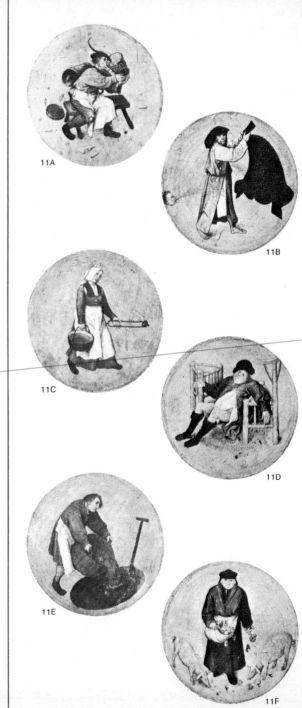

11A

11B

11C

11D

11E

11F

The Triumph of Death (No. 19) (pp. 24–5). *In the foreground, left, a king, a prelate and a wayfarer are all being seized by skeletons, emissaries of death; the same thing will happen to the fool hiding under the table, to the knight unsheathing his sword and to the two lovers absorbed in their music-making.*

The Suicide of Saul (No. 15; detail). *The inscription on the painting tells that the theme is taken from the Bible (I Samuel 31:1–5): the defeated king kills himself by throwing himself on his sword, rather than fall into the hands of the Philistines.*

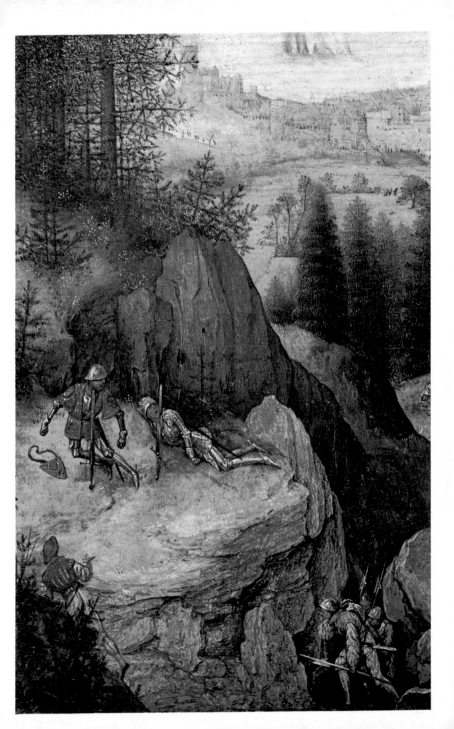

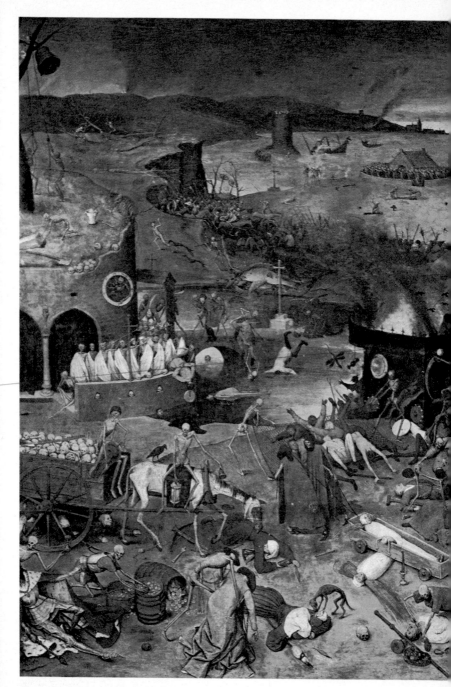

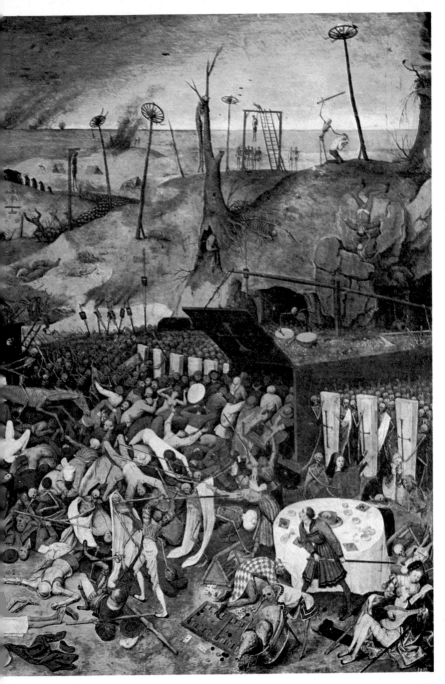

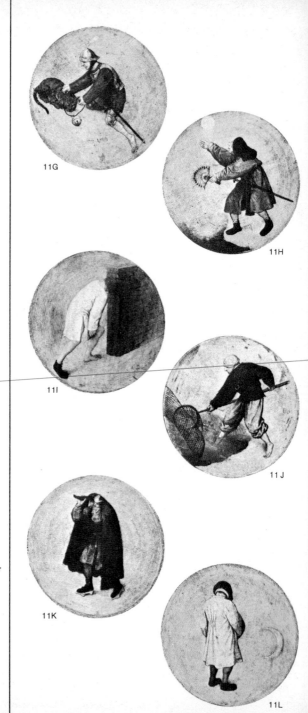

11G

11H

11I

11J

'*Dulle Griet*' (*No. 23*) (*pp. 28–9*). *The absurd figure of Griet, or Mad Meg, is advancing with a fixed, obsessed stare, towards a monstrous mouth; she is surrounded by a great variety of symbols which scholars have interpreted in many different ways.*

The Triumph of Death (*No. 19; detail*). *In the macabre fray, men and women are knocked over, trampled on by the horses of death; those who try to resist are destroyed just the same.*

11K

11L

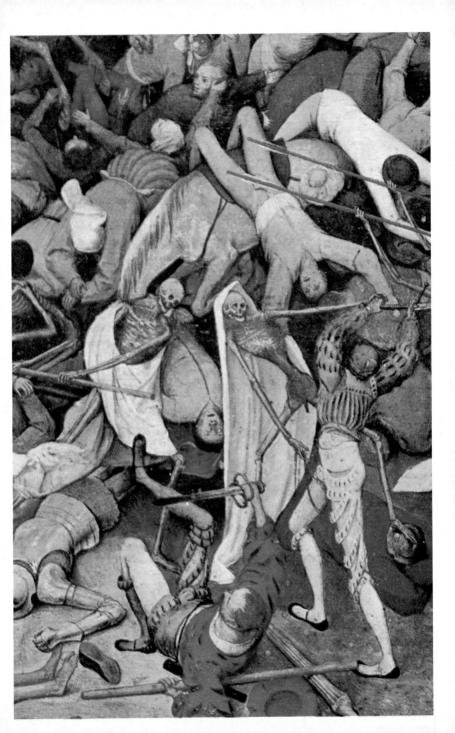

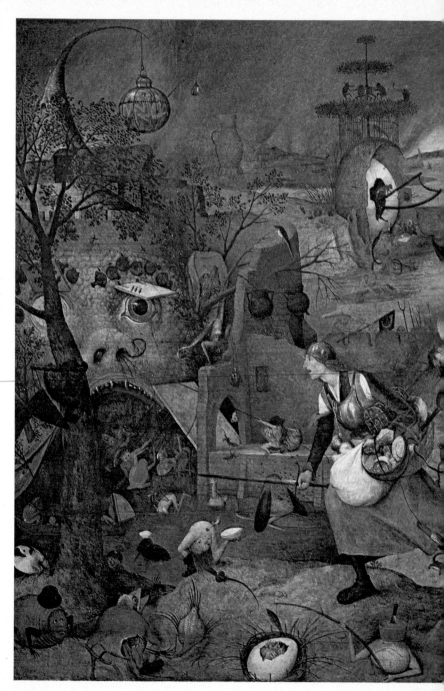

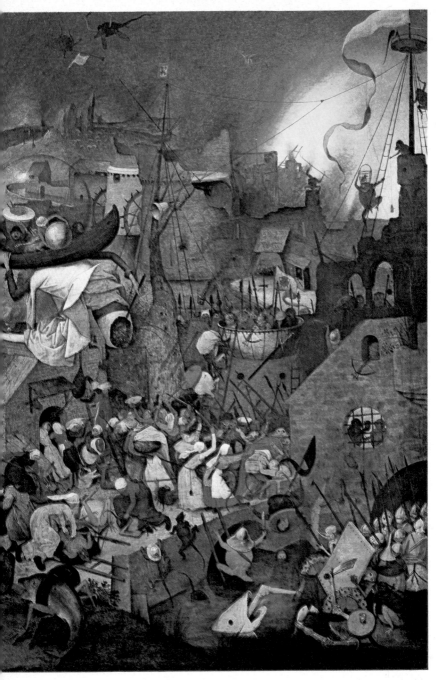

12 Netherlandish Proverbs
Oil on panel/117 × 163/s.d.
1559
Berlin-Dahlem, Staatliche
Museen

**13 The Battle between
Carnival and Lent**
Oil on panel/118 × 164.5/
s.d. 1559
Vienna, Kunsthistorisches
Museum

14 Children's Games
Oil on panel/118 × 161/
s.d. 1560
Vienna, Kunsthistorisches
Museum

*The 'Large' Tower of Babel
(No. 24) (pp. 32–3). The
gigantic construction, with
open sections revealing parts
of the interior, is portrayed
with the precise skill of an
architect; stonemasons swarm
like labouring ants all over it,
among pulleys, scaffolding and
ladders.*

12

13

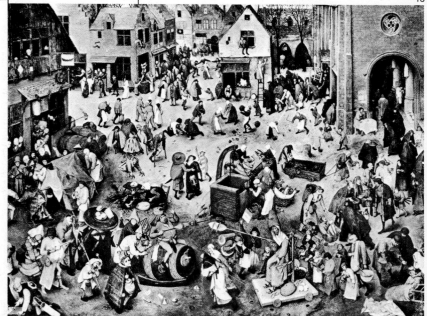

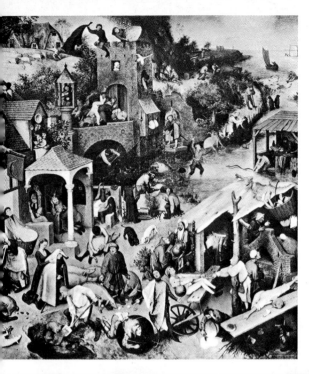

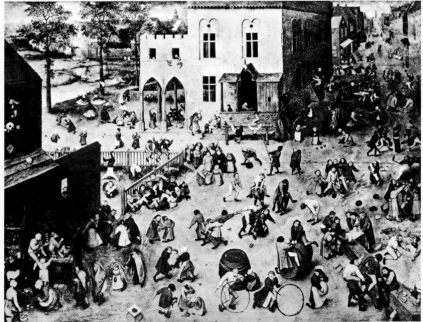

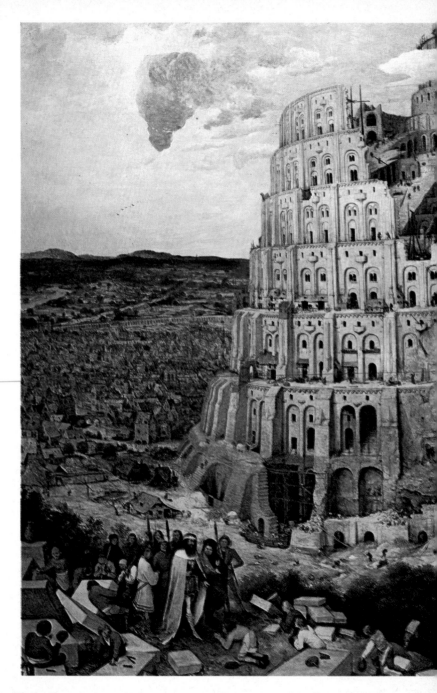

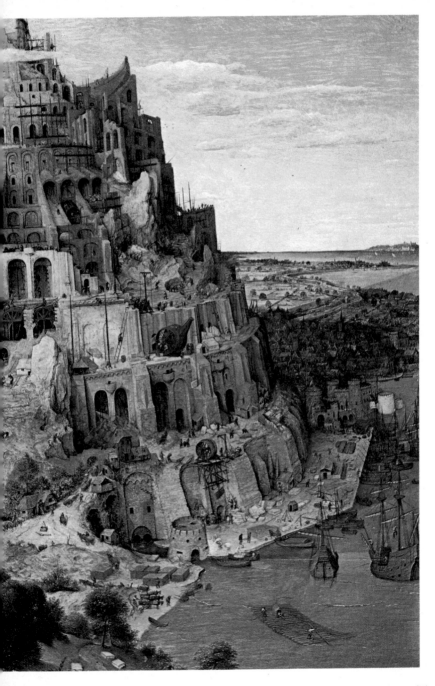

15 The Suicide of Saul
Oil on panel/33.5 × 55/
s.d. 1562
Vienna, Kunsthistorisches
Museum

16 Two Monkeys
Oil on panel/20 × 23/s.d. 1562
Berlin-Dahlem, Staatliche
Museen

17 The Resurrection
Pen and brush on paper
(stretched over a panel)/
43 × 30.7/*c.* 1562
Rotterdam, Museum
Boymans-Van Beuningen
There is an engraving of this
work ('BRVEGEL INVEN. COCK
EXCVDEBAT'; Photo No. 17a)

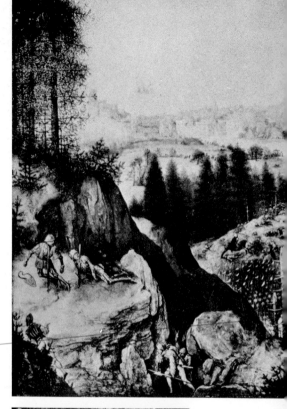

*Christ carrying the Cross (No.
26) (pp. 36–7). The broad
sweep of undulating landscape
lies in a circular pattern
around the enormous rock; the
crowd proceeds towards the
plateau at the top right, where
the crosses have been hoisted.
Christ, in the centre, has fallen
under the weight of his cross,
but his suffering awakens
neither pity nor interest.*

34

17

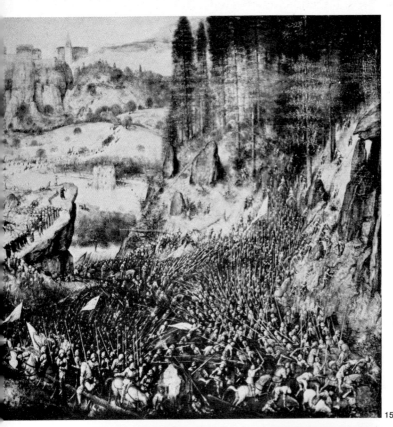

15

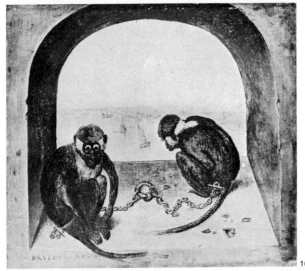

16

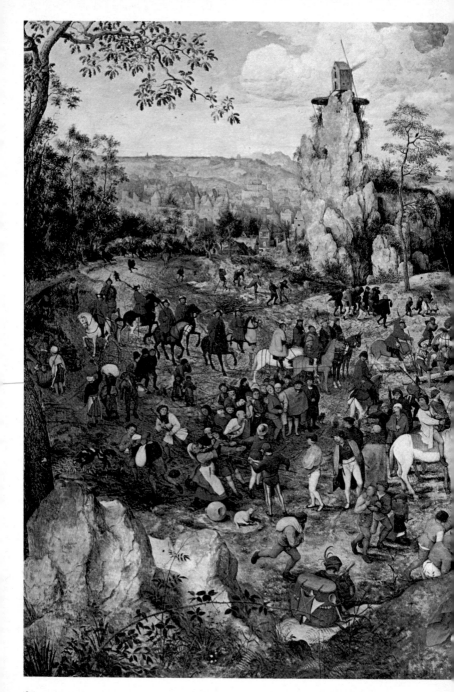

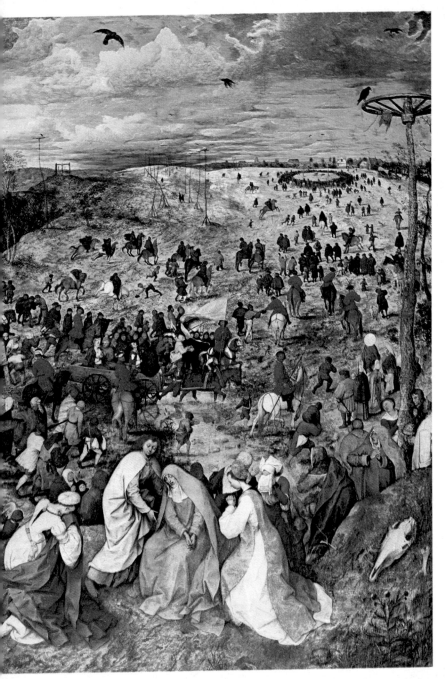

18 The Fall of the Rebel Angels
Oil on panel/117 × 162/s.d. 1562
Brussels, Musées Royaux des Beaux-Arts

Christ carrying the Cross (No. 26; detail). The group of mourners, gathered in the foreground on the right, is drawn with elegant 'Gothic' lines, contrasting in style as well as in mood with the disordered flow of the crowd.

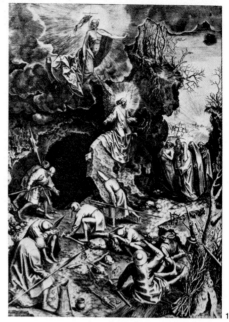

17a

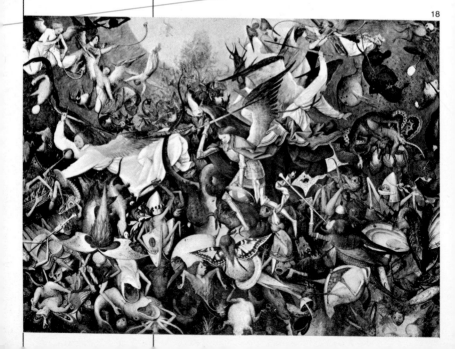

19 The Triumph of Death
Oil on panel/117 × 162/
c. 1562
Madrid, Prado

20 Landscape with St Christopher
Oil on panel/45.5 × 64.8/
1563 (?)
Private Collection
Recent attribution

20

Christ carrying the Cross
(*No. 26; detail*). *The high rock rising off-centre in relation to the painting's axis is nevertheless the pivot of the composition; on it stands a windmill, typical feature of the Netherlands. The bird perched on a branch is an attractive and much employed motif.*

19

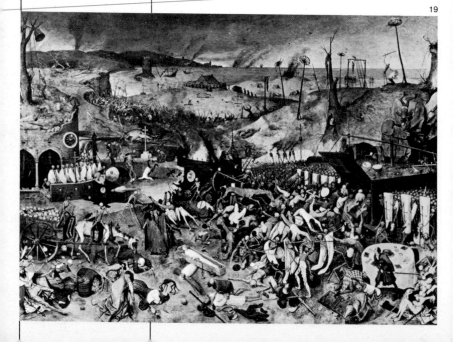

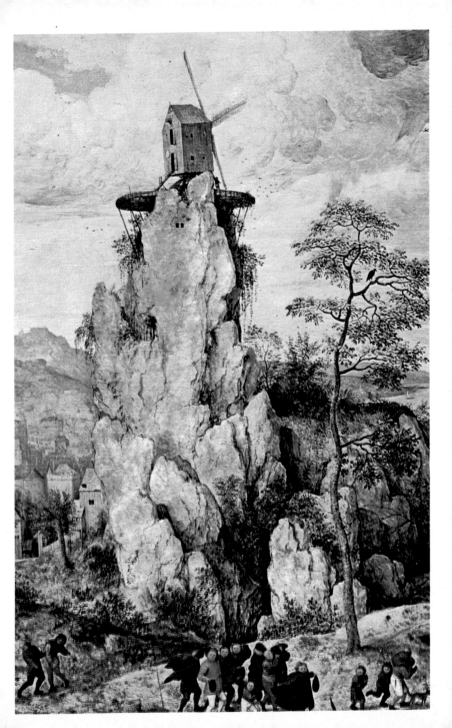

21 Landscape with the Flight into Egypt
Oil on panel/37 × 55.5/
s.d. 1563
London, formerly Seilern
Collection

22 Head of an Old Man
Oil on panel/22 × 18/*c.* 1563
Munich, Alte Pinakothek

22

21

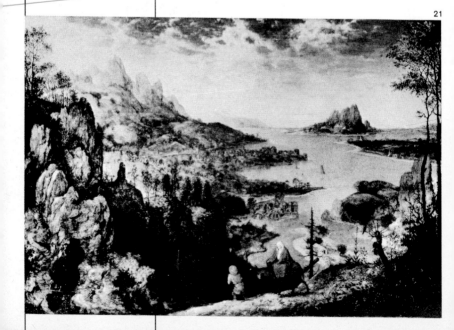

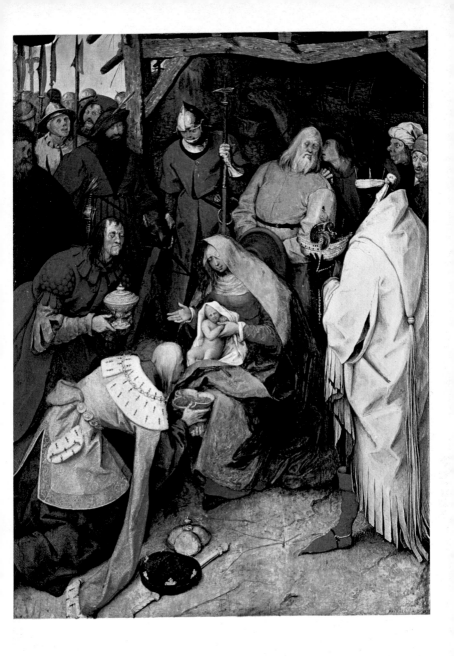

The Adoration of the Magi (*No. 27*). *The compositional plan seems to adhere to the canons of Italian Renaissance painting; the figures and the way the crowd presses forward at the side of the stable are both, however, very original conceptions.*

43

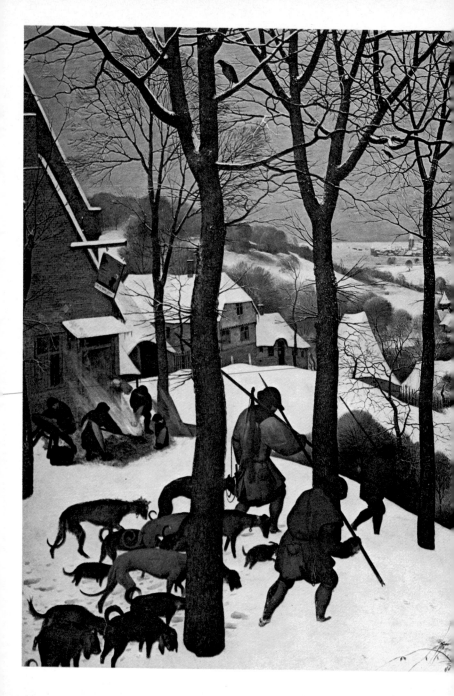

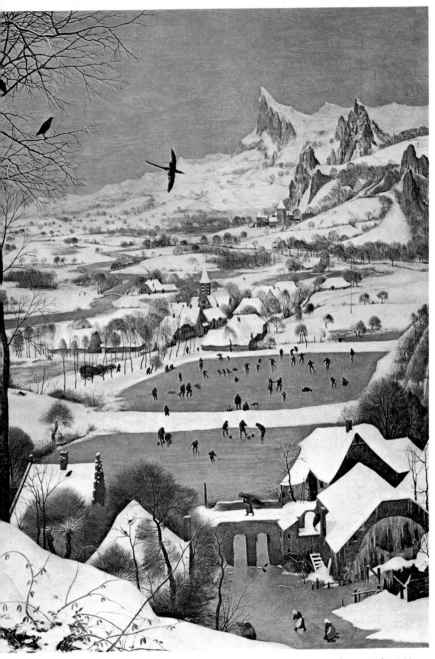

The Hunters in the Snow (No. 30). *This probably represents the month of January with its typical activities and amusements; the figures stand out dark and clear-cut against the snow-covered landscape which is painted in a subtle range of whites and silvery greys.*

23 'Dulle Griet' ('Mad Meg')
Oil on panel/115 × 161/
c. 1563
Antwerp, Museum Van den
Bergh

24 The 'Large' Tower of Babel
Oil on panel/114 × 155/
s.d. 1563
Vienna, Kunsthistorisches
Museum

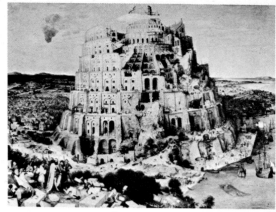

24

The Hunters in the Snow
(No. 30; detail). The snow
projects light among the
interwoven pattern of bare
brown branches, which stand
out against the diffused gleam
of the distant landscape.

23

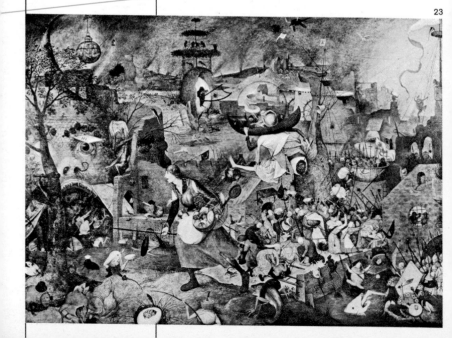

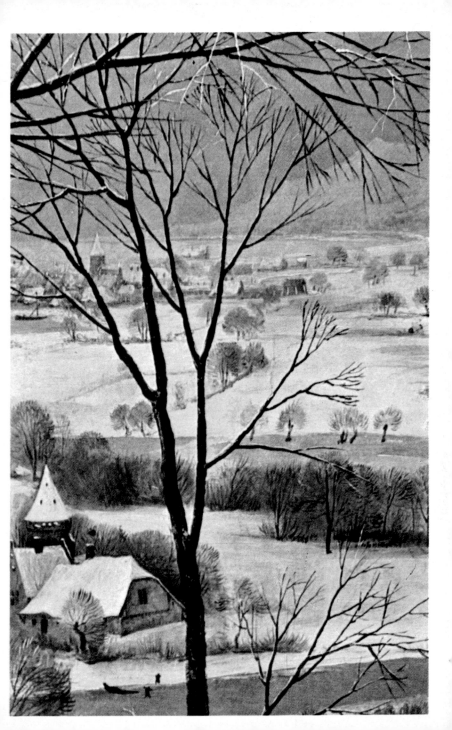

25 The 'Small' Tower of Babel
Oil on panel/60 × 74.5/c. 1563
Rotterdam, Museum
Boymans-Van Beuningen

26 Christ carrying the Cross
Oil on panel/124 × 170/
s.d. 1564
Vienna, Kunsthistorisches
Museum

The Gloomy Day (No. 31; detail). Bruegel's interest in man's labours is one of the most fascinating aspects of his art; his are universal characters, captured as they toil patiently for their everyday survival.

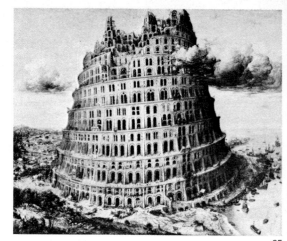

25

26

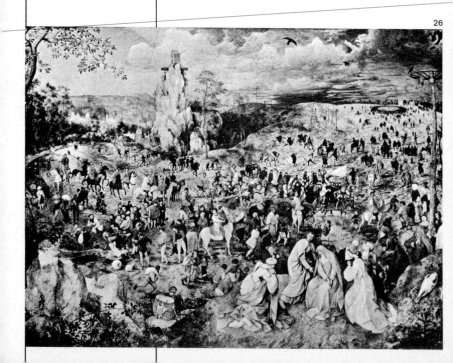

27 The Adoration of the Magi
Oil on panel/111 × 83/
s.d. 1564
London, National Gallery

28 The Dormition of the Virgin
Tempera on canvas/36 × 54.5/
s. c. 1564
Upton House (Edgehill),
National Trust
There exists an engraving
after the work, by Ph. Galle
(Photo No. 28a)

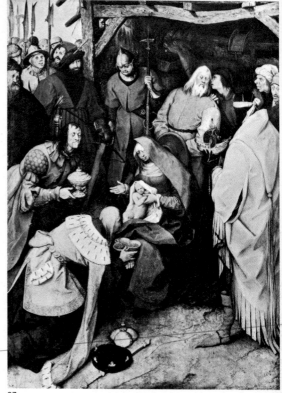

27

28

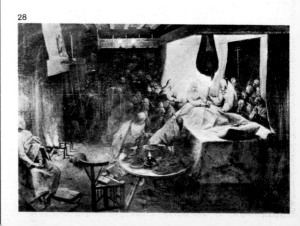

*The Gloomy Day (No. 31;
detail). The oppressive feeling
of the winter's day, dark and
stormy, is portrayed with a
range of dark colours; the
splendour of the snow is made
gloomy with greenish
reflections.*

50

29 Christ and the Woman taken in Adultery
Oil on panel/24.1 × 34.4/
s.d. 1565
London, formerly Seilern
Collection
There exists an engraving
after the work, by P. Perret
(Photo No. 29a)

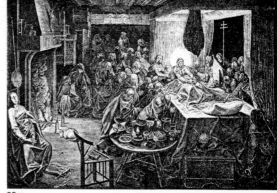

28a

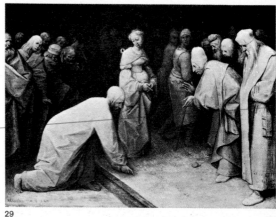

29

29a

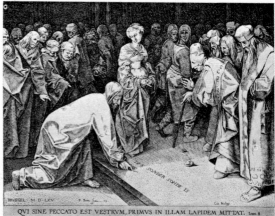

The Harvest (No. 33; detail).
The cornfield is a compact
area of dazzling colour broken
only by the path along which a
peasant is approaching;
beyond, the green of the trees is
dark and opaque.

The Return of the Herd (No.
34; pp. 54–5).
This has autumn colours and a
feeling of melancholy. The
white cow in the middle
looking round seems to involve
the spectator in the scene.

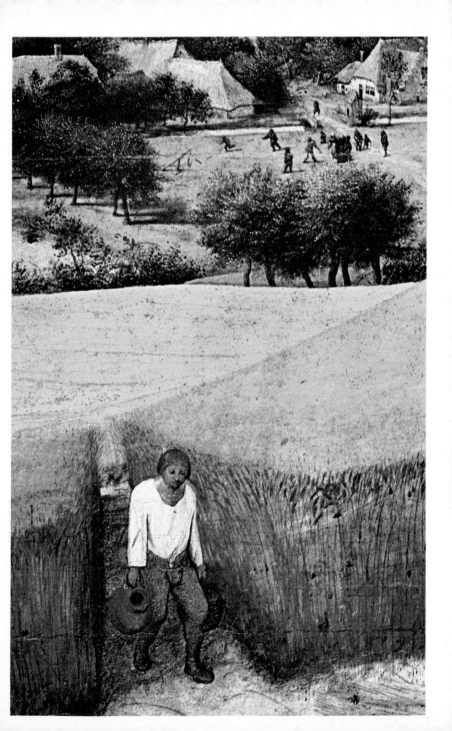

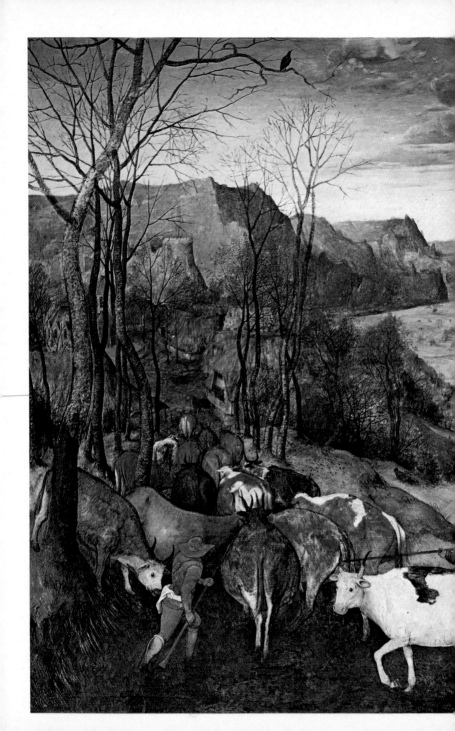

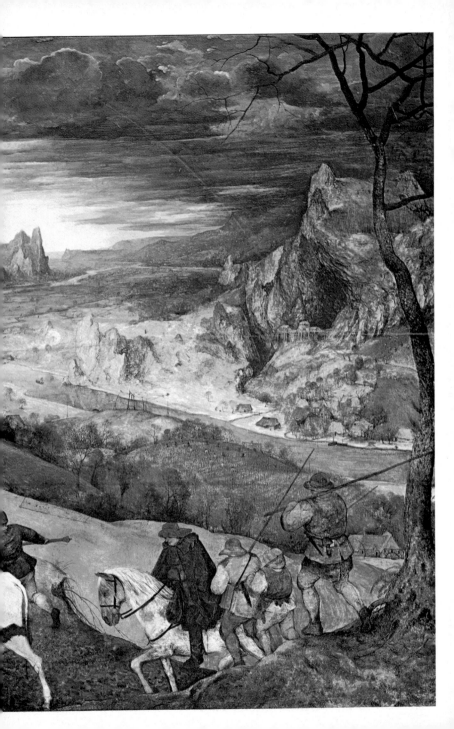

THE MONTHS (Nos. 30–34)

**30 Hunters in the Snow
(*January*)**
Oil on panel/117 × 162/
s.d. 1565
Vienna, Kunsthistorisches
Museum

31 Gloomy Day (*February*)
Oil on panel/118 × 163/
s.d. 1565
Vienna, Kunsthistorisches
Museum

32 Haymaking (*July*)
Oil on panel/117 × 161/
c. 1565
Prague, Národní Galerie
There exists a pen drawing
('BRVEGEL MDLXV [VII or VIII]';
Berlin, Kupferstichkabinett)
which has an iconographical
connection with the
foreground of this work
(Photo No. 32a).

33 Harvest (*August*)
Oil on panel/118 × 160.5/
s.d. 1565
New York, Metropolitan
Museum
There exists a pen drawing of
SUMMER ('BRVEGEL MDLXIII';
Hamburg, Kunsthalle) which
has an iconographical
connection with this work
(Photo No. 33a)

**34 The Return of the Herd
(*October or November*)**
Oil on panel/117 × 159/
s.d. 1565
Vienna, Kunsthistorisches
Museum

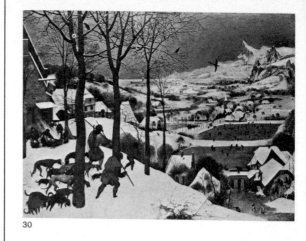

30

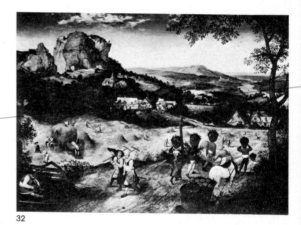

32

32a

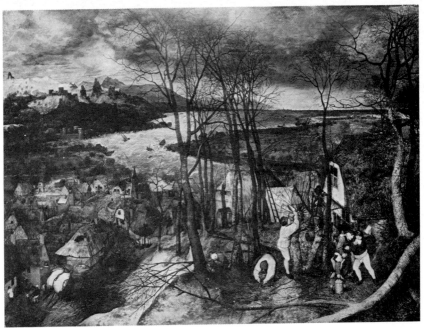

31

34

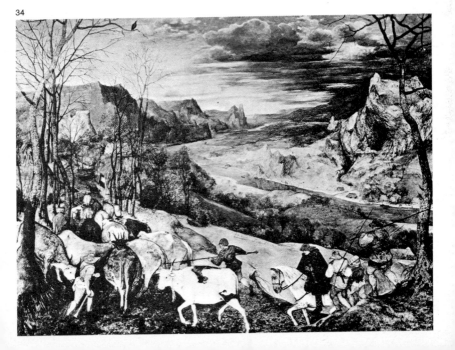

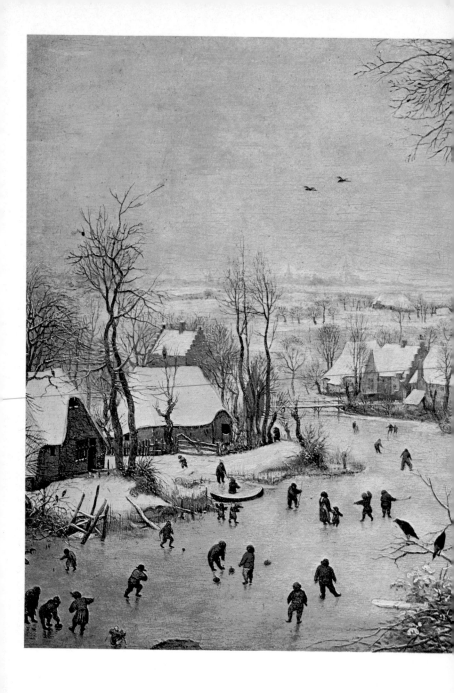

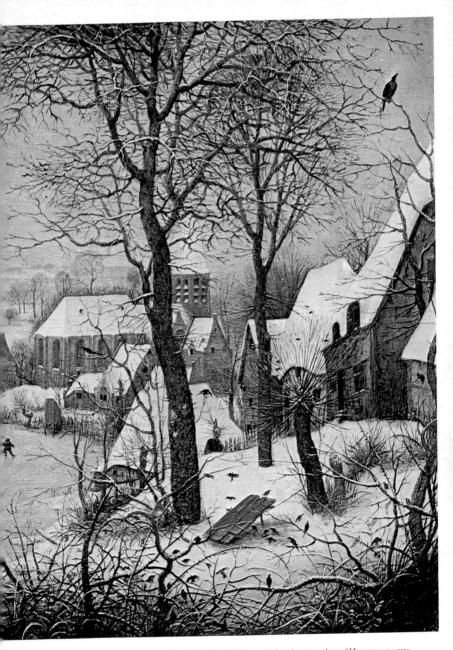

Winter Landscape with Skaters and Birdtrap (*No. 35*). *This is a similar theme to that of* HUNTERS IN THE SNOW, *but instead of the grandeur of that picture, here there is a wonderfully intimate, compact atmosphere.*

The Conversion of St Paul (No. 43; detail). *In the last period of his activity Bruegel used large figures, always in the foreground. The horseman is looking towards his companions on foot and the spectator's gaze is drawn in the same direction.*

33a

33

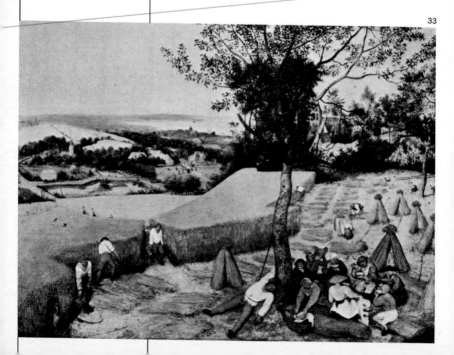

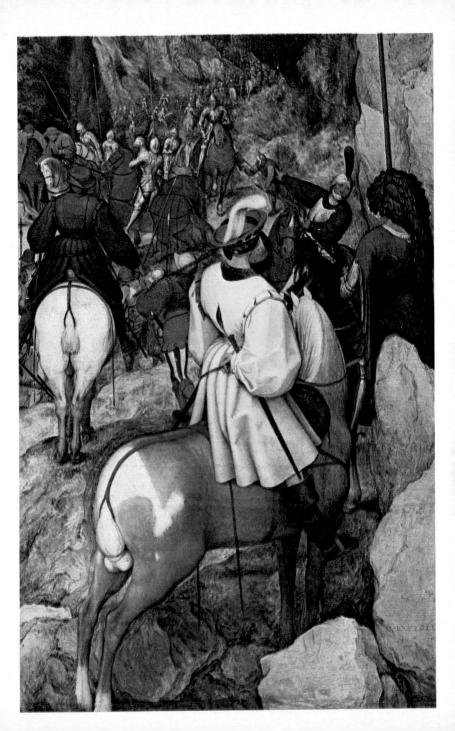

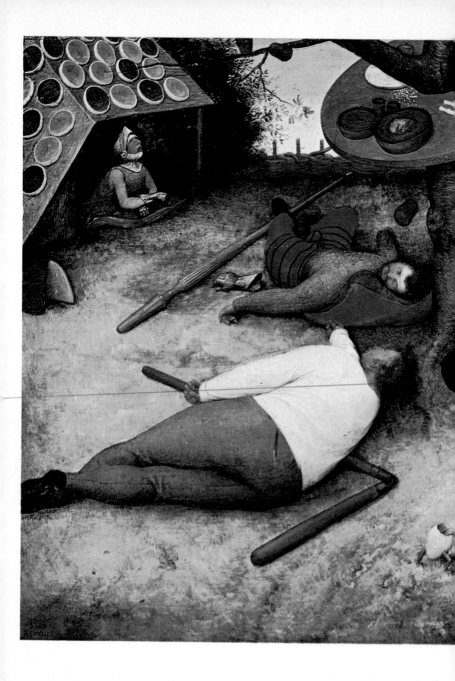

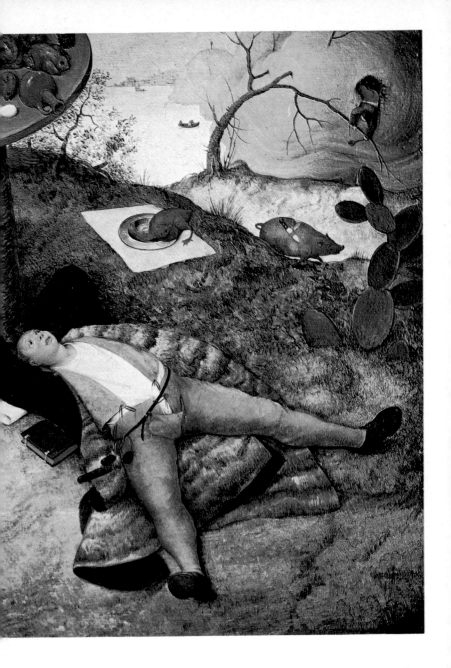

The Land of Cockaigne (No. 45). *The composition is a simple geometric pattern; the characters are inserted into it like the spokes of a wheel, the hub of which is the tree-cum-table.*

**35 Winter Landscape with
Skaters and Birdtrap**
Oil on panel/38 × 56/s.d. 1565
Brussels, Musées Royaux des
Beaux-Arts (F. Delporte
Collection)

**36 Peasants dancing in front of
a Tavern**
Oil on panel/77 × 104.5/
1565 (?)
Paris, Baroness Bentinck
Collection (Netherlands
Embassy)
Attribution

**37 The Numbering at
Bethlehem**
Oil on panel/116 × 164.5/
s.d. 1566
Brussels, Musées Royaux des
Beaux-Arts

**38 The Massacre of the
Innocents**
Oil on panel/116 × 160/s.
c. 1566
Vienna, Kunsthistorisches
Museum

**39 The Massacre of the
Innocents**
Oil on panel/109 × 155/
c. 1566
Hampton Court, Royal
Collection
Version of No. 38

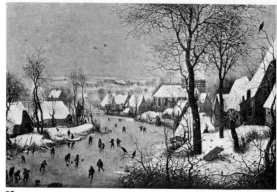

35

36

39

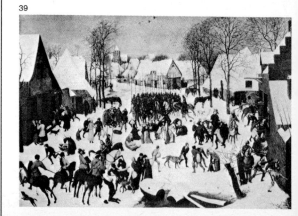

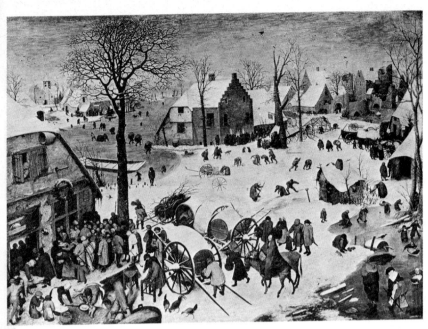

37

38

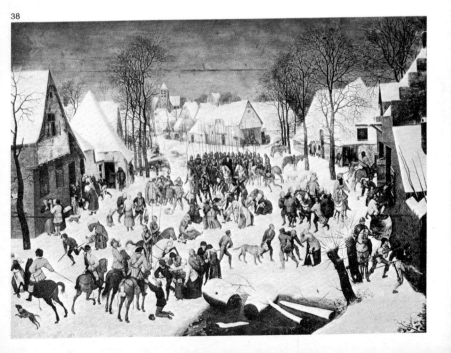

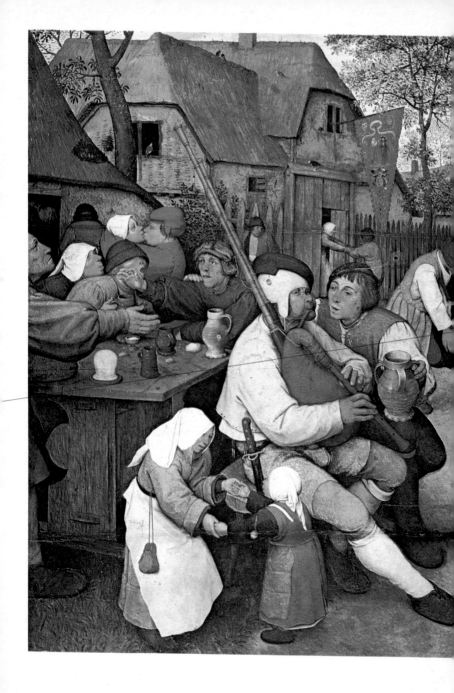

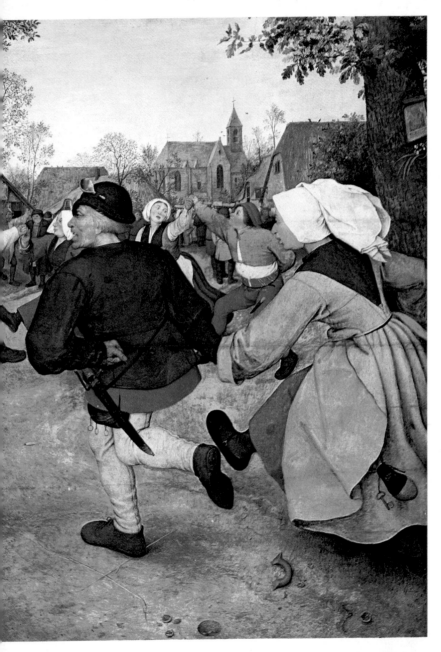

Peasants dancing (No. 46). *The composition, firmly framed by the village houses, seems to be diagonally divided through the middle: the group of drinkers round the table contrasts with the vigorous movement of the dancers in the right foreground, echoed by the couples further back.*

40 Wedding Dance in the Open Air
Oil on panel/119 × 157/
d. 1566
Detroit, Institute of Arts
There are several painted
versions of the work (one of
them at Narbonne, in the
Musée des Beaux-Arts,
attributed to Pieter Bruegel
the Younger; Photo No. 40a)
and also an engraving by
Pieter van der Heyden (Photo
No. 40b)

40a

*Peasants dancing (No. 46;
detail). The characters have
become glassy-eyed with
copious drinking – in some
cases their hats have fallen
right over their eyes; their
gestures are brilliantly
suggested, testifying to patient
study from life over many
years.*

40b

40

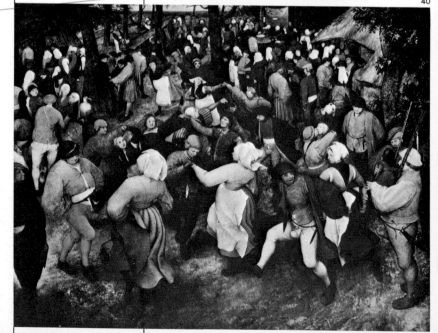

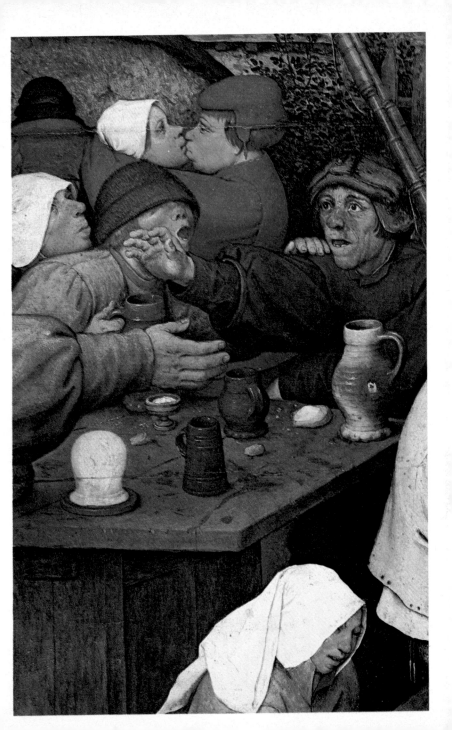

41 St John the Baptist preaching
Oil on panel/95 × 160.5/
s.d. 1566
Budapest, Szépüvészeti
Múzeum

42 Wedding Procession
Tempera on panel/
61.5 × 114.5/c. 1566
Brussels, Musée Communal
Disputed attribution

Peasants dancing (No. 46; detail). *The burly bagpipe-player puffing out his cheeks to blow into his instrument must have been an indispensable figure at every peasant feast; here he is also the key element in the painting.*

41

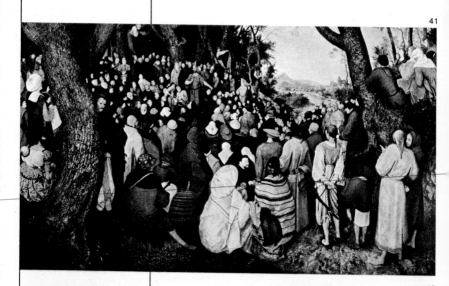

42

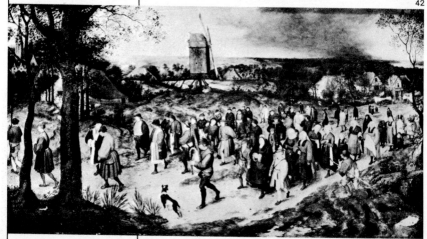

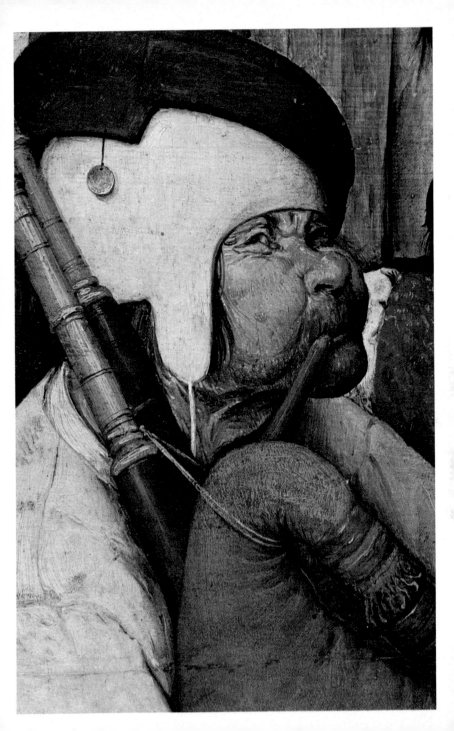

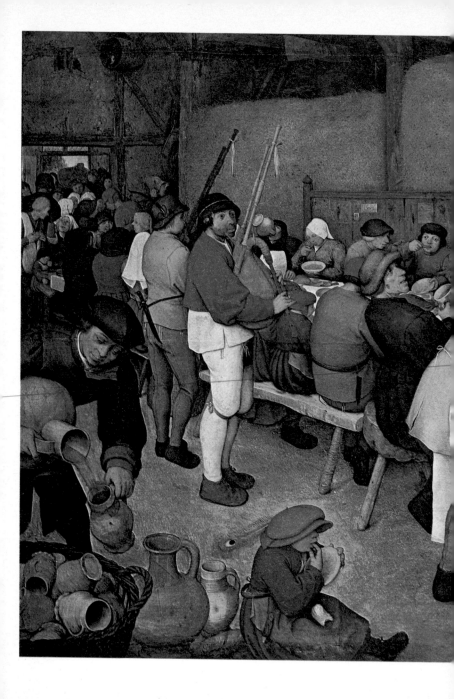

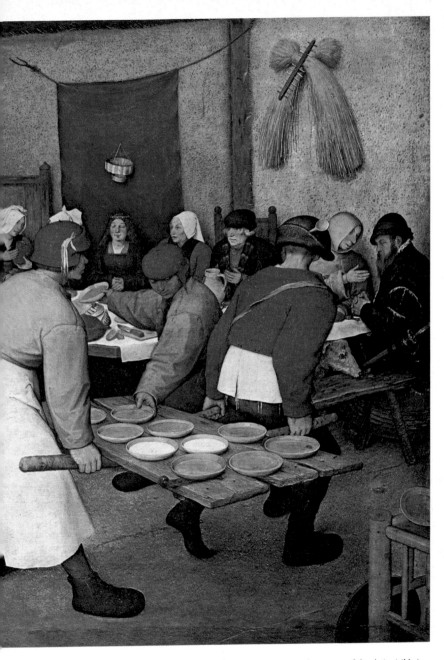

The Wedding Feast (No. 47). *The beautifully balanced composition repeats the pattern of the chair visible in the right foreground. While the bride is immediately identifiable, it is more difficult to pick out the bridegroom who, according to tradition, had to help serve at table; he may be the young man passing plates at the head of the table, or else the one pouring out the wine in the left foreground.*

43

44

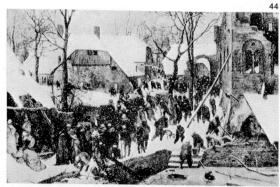

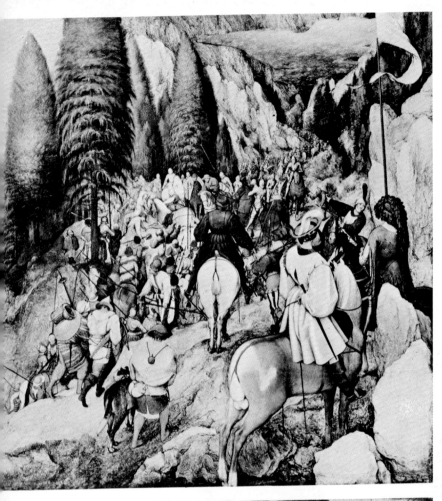

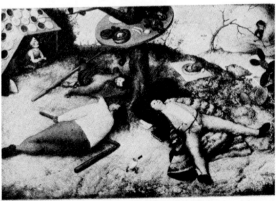

46 Peasants dancing
Oil on panel/114 × 164/s.
c. 1568
Vienna, Kunsthistorisches
Museum

**47 The Wedding Feast (*The
Peasants' Wedding*)**
Oil on panel/114 × 163/
c. 1568
Vienna, Kunsthistorisches
Museum

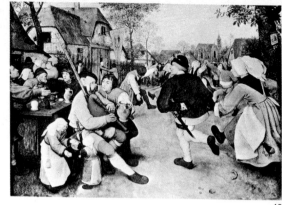

46

*The Wedding Feast (No. 47;
detail). Greedy enjoyment of
food is splendidly expressed by
the child in the foreground, red
hat pulled down over his eyes,
cleaning a plate with his finger.*

47

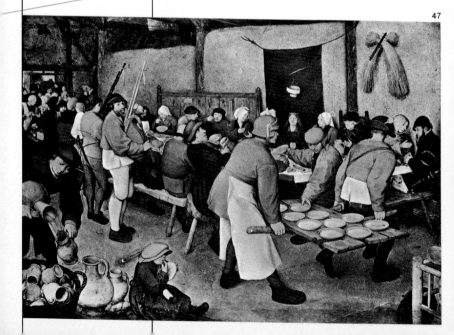

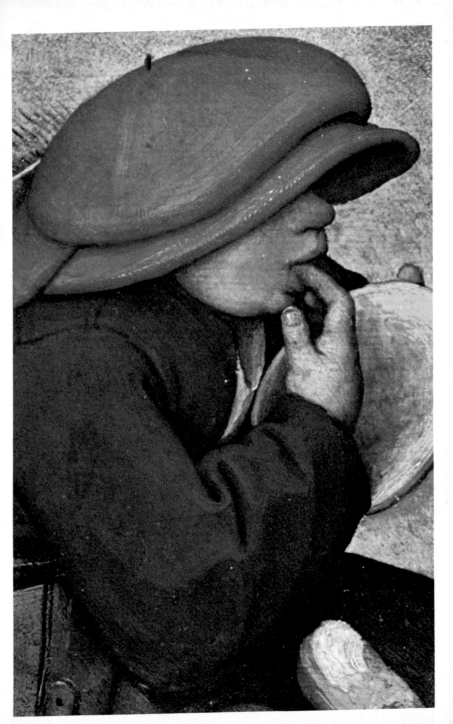

48 The Misanthrope
Oil on canvas/86 × 85/
s.d. 1568
Naples, Museo e Gallerie
Nazionali di Capodimonte
There exists a print connected
with this work, derived from
a presumed original drawing
by Bruegel, formerly at
Amiens (Masson Collection)
(Photo No. 48a)

49 The Parable of the Blind
Tempera on canvas/86 × 154/
s.d. 1568
Naples, Museo e Gallerie
Nazionali di Capodimonte
There exists a pen drawing
('bruegel 1562'; Berlin,
Kupferstichkabinett)
connected with this work
(Photo No. 49a)

50 The Cripples
Oil on panel/18 × 21.5/
s.d. 1568
Paris, Louvre

51 The Birdnester
Oil on panel/59 × 68/s.d. 1568
Vienna, Kunsthistorisches
Museum

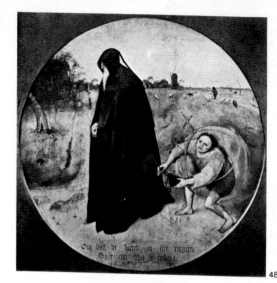

48

48a

51

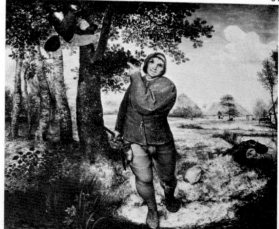

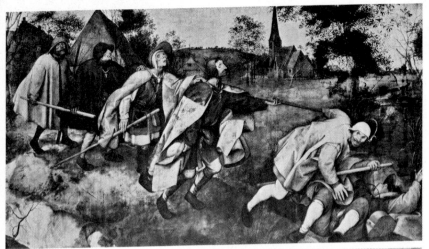

49

49a

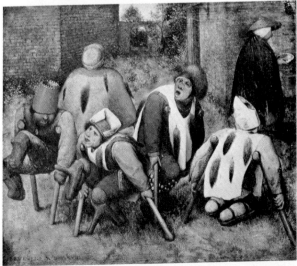

50

52 *The Magpie on the Gallows*
Oil on panel/45.9 × 50.8/s.d.
1568
Darmstadt, Hessisches
Landesmuseum

**53 *Two Peasants binding
Faggots***
Oil on panel/35.5 × 27/
Birmingham, Barber Institute
of Fine Arts
Disputed attribution

54 *The Storm at Sea*
Oil on panel/79.5 × 97/c. 1568
Vienna, Kunsthistorisches
Museum
Possibly unfinished

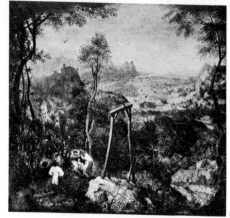

52

53

54

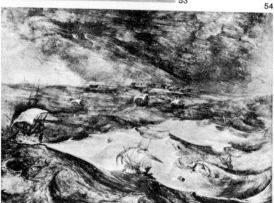

*The Misanthrope (No. 48;
detail). The globe as symbol of
the world recurs many times in
Bruegel; in this case it is
occupied by a pickpocket – in
other words, 'the world is
treacherous'.*

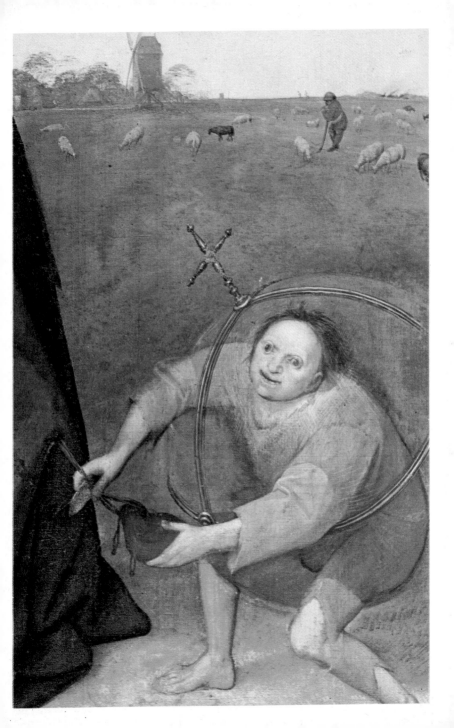

LOST WORKS

55 Shutters of the triptych formerly in the Cathedral of St Rombaud at Malines
Panels/1551
55A St Gomar
55B St Rombaud
The central panel, also lost, was by Peeter Balten

56 View of Lyons
Tempera on canvas/*c.* 1552–3

57 Tree
Tempera on canvas/*c.* 1552–3

58 View of St Gotthard
c. 1553
It may have been copied by Momper (canvas, 209 × 286; Vienna, Kunsthistorisches Museum; Photo No. 58a)

59 Skaters at St George's Gate in Antwerp
1553
Work documented by an engraving by F. Huys (Photo No. 59a)

60 Rustic Wedding
c. 1556
A possible copy (oil on panel, 80 × 186) is in Philadelphia, John G. Johnson Collection (Photo No. 60a)

58a

59a

60a

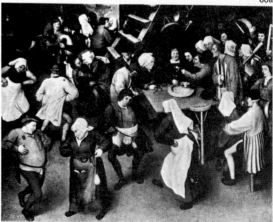

The Parable of the Blind (No. 49; detail). The drama expressed by the empty eye sockets vainly turned towards the spectator is echoed in the unstoppable, desperately groping way the man is falling over the body already stretched out on the ground.

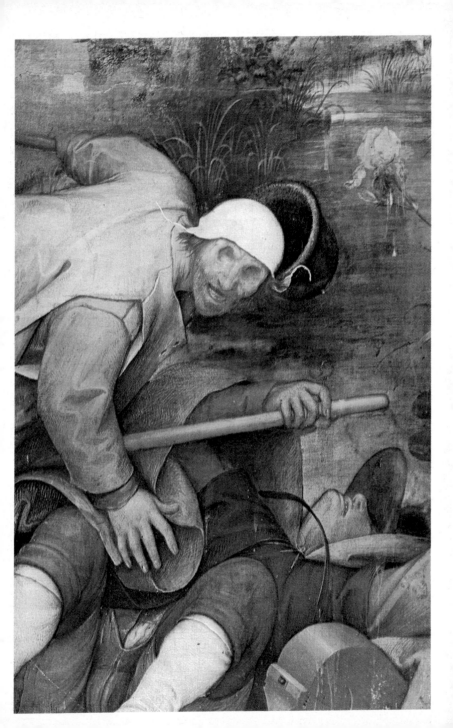

61 The Extraction of the Stone of Folly
c. 1556
A probable copy (oil on panel, 74 × 103) was formerly in Budapest, Palugyan Collection (Photo No. 61a)

62 The Feast of St Martin
c. 1558
A partial copy or work by Jan Bruegel (canvas, 92.5 × 73.5) is in Vienna, Kunsthistorisches Museum (Photo No. 62a)

61a

62a

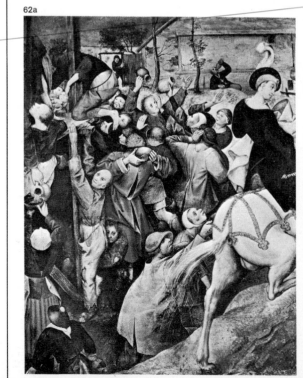

The Parable of the Blind (No. 49; detail). The wretched blind men are bound together by a chain of despair and ruin. Their distressing figures occupy the entire composition.

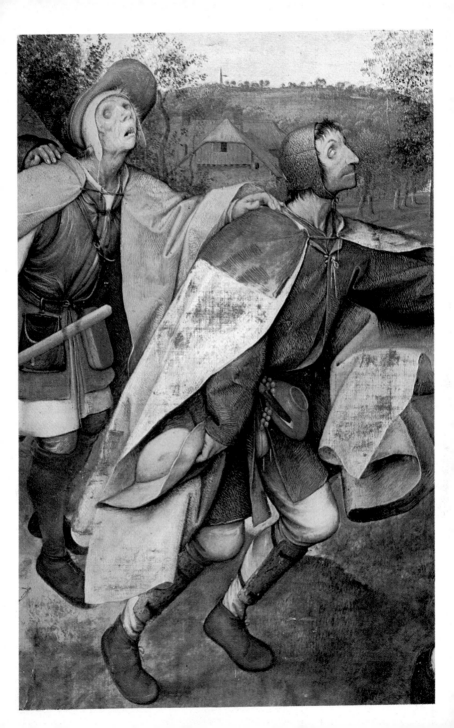

The Birdnester (No. 51). This is an unusual work, difficult to interpret: it might illustrate the Flemish proverb: 'He who knows where the nest is, only knows that; he who steals the nest, has it', or else it might refer to the passage in the Gospels (Matthew 7:3): 'And why beholdest thou the mote that is in thy brother's eye, but considerest not the beam that is in thine own eye?' In fact the Michelangelesque giant pointing to the thief in the tree doesn't realize that he is about to fall into a stream.

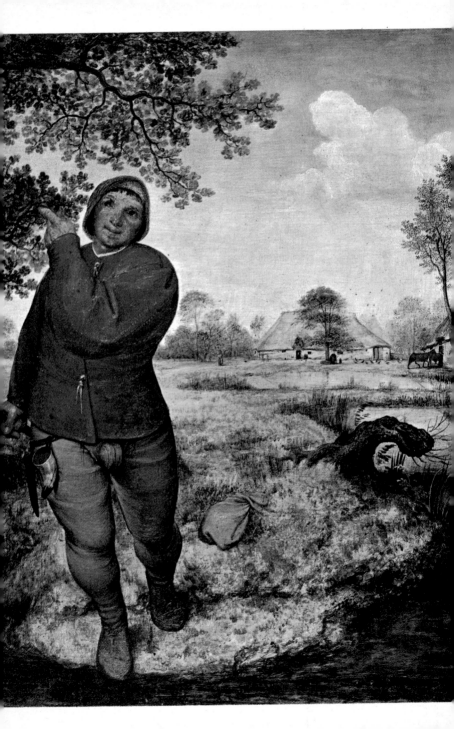

63 Head of a Yawning Man
c. 1558
A probable copy (oil on panel, 12.6 × 9.2) is in Brussels, Musées Royaux des Beaux-Arts (Photo No. 63a)

64 The Wedding of Mopsus and Nisa
c. 1559
Lost painting (or drawing) documented by an engraving by Pieter van der Heyden (Photo No. 64a)

65 The Crucifixion
1559
Copied by, among others, Pieter Bruegel the Younger (Philadelphia, Museum of Art; Photo No. 65a)

66 The Kermis at Hoboken (or at St George)
c. 1559–60
Lost painting (or drawing) documented by copies and engravings (Photos No. 66a and No. 66b)

67 St George on Horseback
Possibly related to No. 66

68 Heathland with Peasants on their Way to Market
Possibly connected with a 17th-century Flemish drawing (Munich, Staatliche Graphische Sammlung; Photo No. 68a)

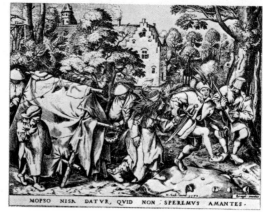

MOPSO NISA DATVR, QVID NON SPEREMVS AMANTES·

64a

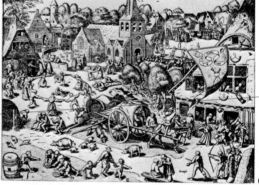

66a

65a

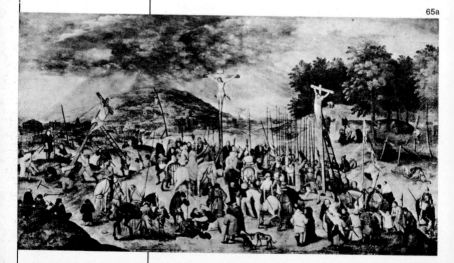

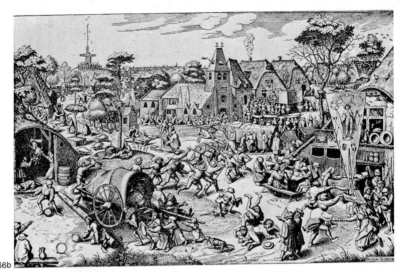

66b

63a

68a

69a

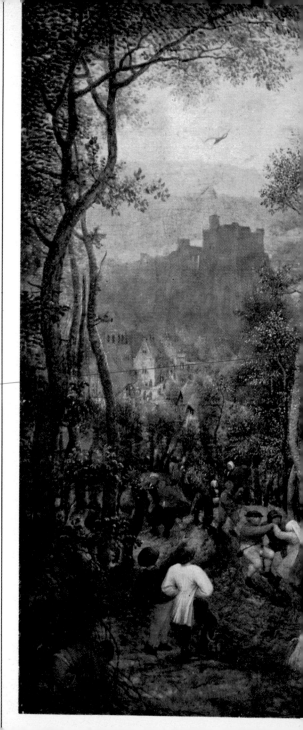

**The Magpie on the Gallows
(No. 52).** *The vast, beautiful
landscape bathed in light is
one of the best Bruegel ever
painted. The little groups of
dancing peasants fit into it
well, but the menacing gallows
in the foreground are a dismal
and pessimistic reminder of
reality.*

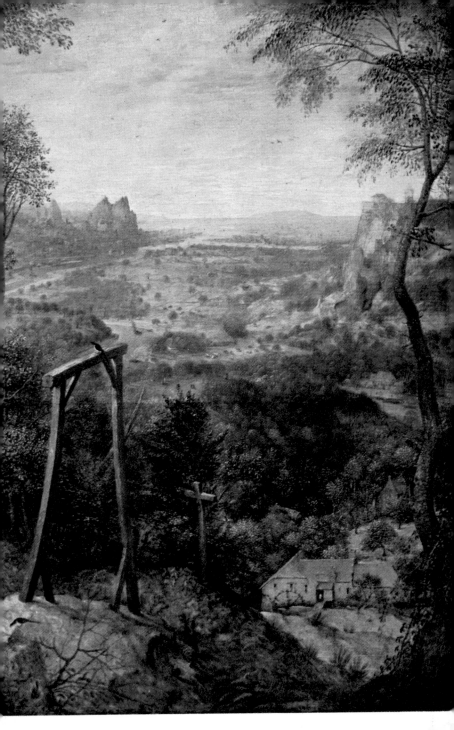

69 The Sacking of a Village
c. 1566
Possibly related
iconographically to a painting
by Pieter Bruegel the
Younger (Douai, Musée des
Beaux-Arts; Photo No. 69a)

70 Quarrelling Card-Players
c. 1566
Lost painting (or drawing?)
documented by an engraving
by L. Vorsterman (Photo
No. 70a)

71 The Good Shepherd
c. 1566–8
A possible copy is by Pieter
Bruegel the Younger (panel,
40 × 54.5) in Brussels, P.
Kronacker Collection (Photo
No. 71a)

72 The Hireling Shepherd
c. 1566–8
A possible copy (oil on panel,
77 × 88) is in Philadelphia,
John G. Johnson Collection
(Photo No. 72a)

73 'Back to your Sty, you Pig!'
c. 1568
Work engraved by J.
Wierix (Photo No. 73a)

74 Blind Man playing a Hurdy-Gurdy
c. 43 × 60/*c.* 1568
There exist copies by Pieter
Bruegel the Younger

75 Gentlemen visiting a Farm
c. 1568
Documented by many copies
and also perhaps by a copy in
grisaille (panel, 30.5 × 46.5) in
Antwerp, Koninklijk
Museum (Photo No. 75a)

76 The Triumph of Truth (or of Time)
c. 1569
Possibly connected with the
engraving by Ph. Galle
(Photo No. 76a)

***Storm at Sea (No. 54; detail)
(pp. 94–5). This is one of the
most intensely dramatic of
Bruegel's paintings: the ship
violently shaken by the
elements seems to symbolize
the life of man, whose only
possibility of salvation is to be
found in religion (represented
by the church in the
background).***

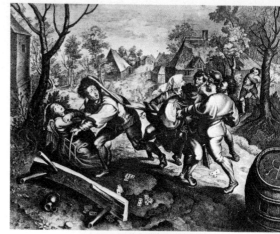

70a

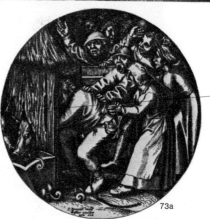

73a

72a

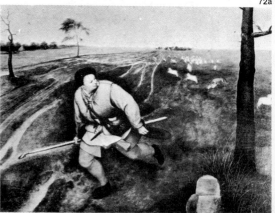

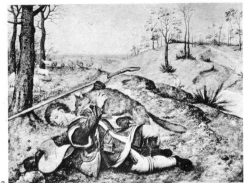

71a

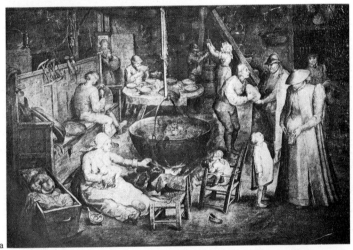

75a

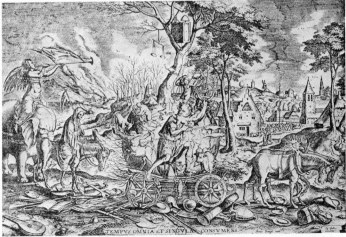

TEMPVS OMNIA ET SINGVLA CONSVMENS.

76a

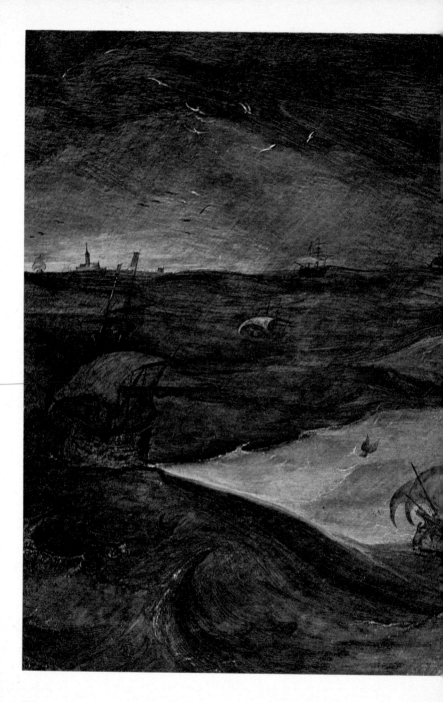

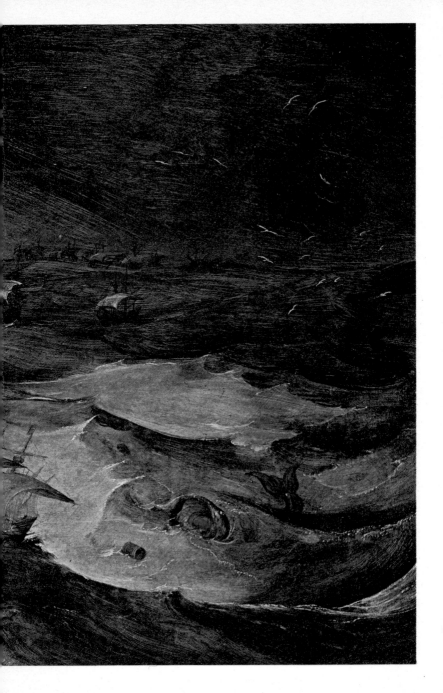

Bibliography

An exhaustive summary of the bibliography on Bruegel is provided by E. MICHEL (*Bruegel*, Paris 1931; and *Musée National du Louvre . . . Peintures flamandes du XVᵉ et du XVIᵉ siècle*, Paris 1953) and by F. GROSSMANN (*Encyclopedia of World Art*).

For biographical information there are very few sources (L. GUICCIARDINI, *Descrittione di tutti i Paesi Bassi . . .*, Antwerp 1567; C. VAN MANDER, *Het Schilderboek*, Haarlem 1604) and these are supplemented by inventories and catalogues of collections of archive documents; an extensive examination of the documents has been made by R. VAN BASTELAER and G. HULIN DE LOO (*Peter Bruegel l'Ancien, son oeuvre et son temps*, Brussels 1905–7) and by G. GLÜCK (*Peter Bruegel des Älteren Gemälde im Kunsthistorischen Hofmuseum zu Wien*, French translation, Brussels 1910).

General studies, in addition to those already mentioned, include the following: M. J. FRIEDLÄNDER, *Pieter Bruegel der Ältere*, Berlin 1921, 2nd edn 1964; M. DVOŘÁK, *Pieter Bruegel der Ältere*, Vienna 1921; CH. DE TOLNAY, *Pierre Bruegel l'Ancien*, Brussels 1935; M. J. FRIEDLÄNDER ('Pieter Bruegel', in *Die altniederländische Malerei*, XIV, Leyden 1937; G. JEDLICKA, *Pieter Bruegel, Der Maler in seiner Zeit*, Erlenbach-Zürich 1938, 2nd edn 1947; W. VANBESELAERE, *Pieter Bruegel en het Nederlandsche Maniërisme*, Tielt 1944; R. GENAILLE, *Pierre Bruegel l'Ancien*, Paris 1953; G. GLÜCK, *Das grosse Bruegel-Werk*, Vienna 1951; F. GROSSMANN, *Bruegel. The Paintings*, London 1955, 3rd edn 1973; C. G. STRIDBECK, *Bruegelstudien*, Stockholm 1956; R. L. DELEVOY, *Bruegel, Etude historique et critique*, Geneva 1959; L. VAN PUYVELDE, *La peinture flamande au siècle de Bosch et Brueghel*, Paris 1962; R. H. MARIJNISSEN and M. SEIDLER, *Bruegel*, Stuttgart 1969; W. STECHOW, *Pieter Bruegel the Elder*, New York 1970.

For the graphic work see in particular: R. VAN BASTELAER, *Les Estampes de Peter Bruegel l'Ancien*, Brussels 1908; CH. DE TOLNAY, *The Drawings of Pieter Bruegel the Elder*, 2nd edn, London 1952; L. MÜNZ, *Bruegel. The Drawings*, London 1961; H. A. KLEIN. *Graphic Worlds of Peter Bruegel the Elder*, New York 1963.

Photocredits

Antwerpen, Museum Mayer van den Bergh: p. 11, pp. 12–13. Bildarchiv Preussischer Kulturbesitz: pp. 28–9. All other colour and black and white pictures are from the Rizzoli Photoarchive.

First published in the United States of America 1980 by Rizzoli International Publications, Inc.
712 Fifth Avenue, New York, New York 10019
Copyright © Rizzoli Editore 1979
This translation copyright © Granada Publishing 1980
ISBN 0-8478-0309-0
LC 80-50234
Printed in Italy